COLOR +
PATTERN

COLOR +
PATTERN

50 playful exercises for exploring pattern design

Khristian A. Howell

ROCKPORT

Quarto is the authority on a wide range of topics.

Quarto educates, entertains and enriches the lives of
our readers—enthusiasts and lovers of hands-on living.

www.QuartoKnows.com

First published in the United States of America by
Rockport Publishers, an imprint of
Quarto Publishing Group USA Inc.
100 Cummings Center
Suite 406-L
Beverly, Massachusetts 01915-6101
Telephone: (978) 282-9590
Fax: (978) 283-2742
www.QuartoKnows.com
Visit our blogs at www.QuartoKnows.com

Library of Congress Cataloging-in-Publication Data available

ISBN: 978-1-63159-041-2

Digital edition published in 2015
eISBN: 978-1-62788-360-3

10 9 8 7 6 5 4 3 2

Design: Niki Malek
Photo: page 28, Igor Matie/shutterstock.com

Printed in Canada

To Keli, who takes my hand as we close our eyes, and then whispers, *jump, the net will appear—and if not, I'll catch you.*

CONTENTS

PREFACE

Sometimes, I feel like that kid in *The Sixth Sense*. You know the famous line—I know you do. Well, my line is, "I see pattern. I see it *everywhere!*" What's surprising to me is that few people realize how much they see it too. Pattern is everywhere, on almost everything. Pattern influences countless consumer decisions: Should I buy this floral dress? Do I like the journal with the stripes or the dots? How should we arrange these tiles in the bathroom—in a grid or a herringbone pattern?

The amazing thing about great pattern design is that pattern and product are often one and the same to consumers. They are inseparable. They're bound together and work together to convey a feeling and message about the product—pretty powerful stuff, right? Pattern is the silent, pervasive piece of design that's often overlooked. Sometimes, design is so good, it seems as if it were spontaneously born. Great design makes it look like it should be this way, and nothing else would make sense. I think successful pattern design execution falls into this category. There's a new zest for all things print and pattern.

Curious and ready to play? Great! Let's do it! Through the next fifty exercises you will discover many technical things about the anatomy of patterns and how to create them. Sounds good, right? However, before you can do that, you have to see the world through new eyes. I will take you through exercises that will help you see things differently, finding patterns in places you never noticed. This is when the magic really starts to happen. Have you ever noticed the pattern of a slice of kiwi? Have you ever stopped to observe the texture of the different trees and foliage you encounter on a walk? I've spent years living, breathing, and studying color and pattern, first for a major retailer, and now as an independent artist and designer. By the end of this book, you too will be seeing pattern everywhere you go.

THE IMPACT OF PATTERN DESIGN

Imagine you're strolling through your favorite clothing store. There among the sea of racks and pretty displays you instinctively make a choice—a choice about what you will check out first. Broadly speaking, upon first glance you wouldn't able to see the cut or shape of any of the garments as they hang on the racks. You would, of course, be able to distinguish the basics, like a long or short garment, coats, pants, and so on. However, you wouldn't be able to see the details of the garment design. So what's that first level of attraction that pulls you in one direction or another? Without a doubt it's color. What's a close second? Not surprisingly, it's pattern. These two elements are vital in that split-second first impression that will either attract or repel a consumer from a product. Color and pattern have the power to elicit an instant emotional attachment to an item. Often, this attachment can dictate the consumer's choices in a market full of similar, competing products. This holds true across many different product categories, from textiles and paper goods to home décor and accessories. Stop and consider this the next time you're perusing the marketplace.

This is pretty powerful stuff, and it's part of the reason I find working with color and pattern so intriguing. We all like to own items that feel like an expression of who we are. The resurgence of print and pattern in all facets of design has given the consumer a myriad of ways to specifically assert a fierce sense of identity and personality. In my book, it's a pretty great privilege to be a part of helping others to express that individuality.

GLOSSARY OF ESSENTIAL TERMS

CHEVRON
A zigzag design executed in a stripe layout.

COLLECTION
A group of designs that are linked by a common thread, such as color, subject, or style.

CONVERSATIONAL
A pattern using a recognizable design as a motif, such as umbrellas or dogs.

DIRECTIONAL
A design in which motifs are oriented along one or several directions. Also a design that looks correct when viewed from only one orientation.

ETHNIC
Designs originating from a particular country or culture.

FLORAL
A design using flowers and other nature elements, such as seedpods, leaves, or vines.

FOULARD
A soft, light fabric of plain or twill weave in silk or rayon. Patterns are typically small and in rich, dark, masculine colors—typically used for scarves and men's ties. The type of pattern is also referred to as foulard.

GEOMETRIC
Motifs made up of simple shapes like lines, squares, and circles.

GINGHAM
A small, even plaid pattern that is typically woven and is executed in one color.

GROUND
The layer of the design that seems to be the farthest away from the viewer on which all other motifs seem to rest. May be a solid color, textured, or patterned.

HOUNDSTOOTH
A duotone textile pattern characterized by broken checks or abstract, four-pointed shapes, often in black and white, although other colors are also used.

IKAT
A technique originating in Southeast Asia where either the wrap or weft yarns are resist dyed before weaving. The look is commonly re-created digitally today.

MOTIF
A decorative design.

OGEE
An onion-shaped motif.

PAISLEY
A stylized, teardrop-shaped design.

PATTERN
The regular repeating of a motif.

PLAID
A pattern of intersecting horizontal and vertical lines that is traditionally woven, but is also executed as a printed design.

PRINT
A term that may be used to describe a pattern design.

REPEAT PATTERN
A term used to describe a type of artwork in which a motif or set of motifs is duplicated over and over to create a design. Repeat patterns are commonly used in textiles, stationery items, and so on.

SURFACE DESIGN
A term used to describe the artwork that adorns the surface of a product or object.

TILE
The unit containing the motifs that, when duplicated, and combined in a uniform manner, create a repeat pattern design.

TOSSED
A design in which the motifs are arranged so that they're rotated in many directions. A tossed design has no right side up.

GATHERING INSPIRATION

When I'm in the beginning stages of developing new patterns or collections, my studio looks like a war room. I pull out samples I love (both new and archived); countless magazine tears cover my desk, and fresh flowers usually fill the room. I *crave* imagery to get the creative flow going. Those images are amassed from a variety of sources: Fashion, travel, and exploring new sights, cultures, and experiences are the trigger points for me. In the moments when I'm immersed in these experiences, I feel the most creatively free.

Inspiration has become a big topic of discussion in creative fields as of late, mainly because both major retailers and independent creatives have taken strong liberties with the concept. Finding your personal inspiration is *not* copying, slightly altering, or reworking existing work—*especially* if it's not your own. True inspiration is meant to help us tap into the endless well of creativity that's already within all of us. This, for example, is why Paris is my personal go-to place for revisiting this well. Yes, of course it's a beautiful destination and clearly full of visual stimulation. However, inspiration is so much more that for me. Some of my most creative and

energizing sparks of inspiration have come while simply sitting in a café *feeling* the essence of the place and the moment in time. Finding true inspiration is about an emotion or feeling that's sparked from deep within. It's this feeling we're compelled to relay to the world in the form of creative expression.

We spend a good amount of time in this book exploring different ways to tap into this feeling, this well of creativity, this endless resource of inner inspiration. You don't have to go all the way to Paris to find it. You simply have to be willing to see the world around you in new ways.

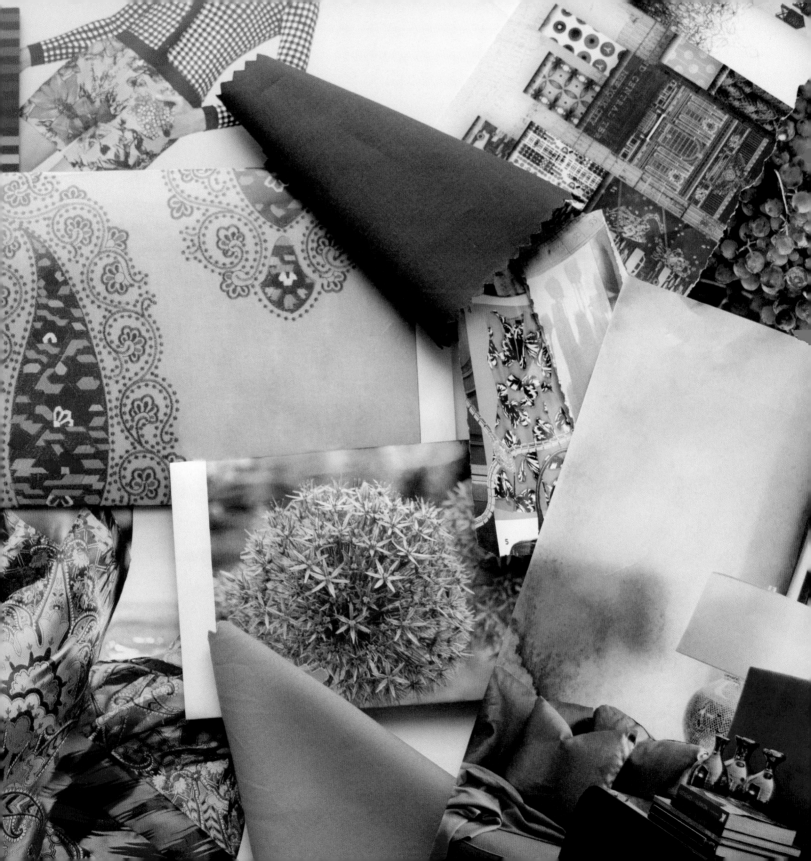

01

START AN INSPIRATION JOURNAL

We're all very visual beings. That's why you're reading this book—because you love the visual arts, color, pattern, and everything beyond and in between. Although it's true that finding your deep spark of inspiration starts with or creates a feeling, at the end of the day we want to interpret that feeling into something visually beautiful. An inspiration journal will help you keep images you've collected or created safe for when you're ready to reference them.

Your inspiration journal will help you to make sense of all the beautiful images you encounter. For me, it's an unedited space for me to just explore images that make me happy or create that feeling. Some of the pieces are purely for color inspiration. Others inspire the style I'm going for. Still others are for shape concepts. You get the idea. Compiling all of this is what helps make the vision really come together.

First things first: You get to buy a new notebook! Ahhhhh . . . that's the sound of those angels singing! If you're like me, you're obsessed with and extremely particular about your sketchbooks and notebooks. Am I right? So go and pick up a new beauty.

Next, start collecting. All of those images—and maybe some stationery samples, magazine tears, photos you took, and so on—go right into the journal. I change my mind and get over images pretty quickly, so I use paperclips instead of staples to keep them in place. Write notes, sketches, or doodles next to your images if you have ideas about what to do with them.

Don't worry if you fill your journal up fast. Just start another one!

Treat yourself to a new journal. If you're like me, it will become your little treasure.

● *YOUR MISSION*

Pick up a new journal that you dedicate to collecting inspiration. Then, fill her up! And be sure to play! play! play! Do not edit yourself in this process. If an image grabs you, grab it! You'll have plenty of time down the road in your design process to edit.

Mary Beth Freet of Pink Light Studio sees the whole world as a visual candy store. She is constantly photographing and collecting inspiration from magazines, samples, retail, and travel.

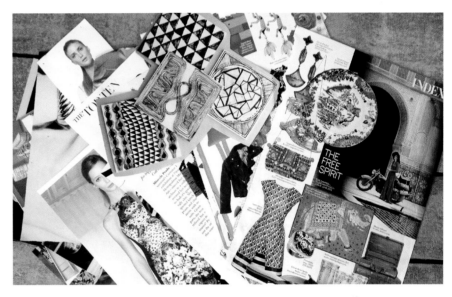

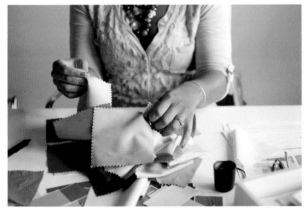

I keep and collect anything that spurs my creative flow—scraps of paper, scraps of fabric—whatever it is that sparks the fire.

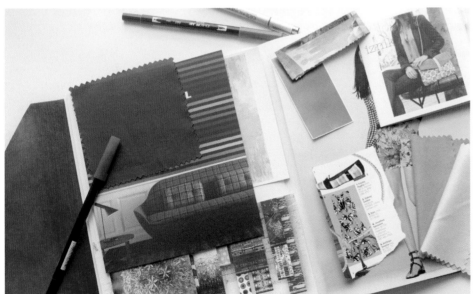

Your inspiration journal is the perfect place to brain dump. Grab every image, tearsheet, and sample you love. You have plenty of time to edit later!

TIP

Put the date on the inside cover of your new journal. If you're inclined to save all your journals, you'll get a good chuckle a few years down the road. Plus you'll be prepared with true vintage inspiration when that print trend you hoped would die comes circling back into the market!

02

STUDY A BOUQUET OF FLOWERS

Nature is always a big source of inspiration for most artists. Even on the gloomiest of winter days, I love having fresh flowers in my space for a shot of life and color. They are great not only for floral inspiration but also for all the abstract nuances you can see when you look closely.

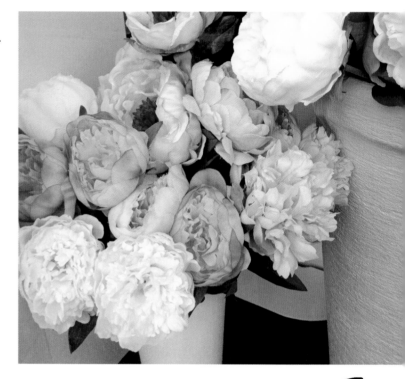

● *YOUR MISSION*

• Your mission for today is to go buy flowers! Then pull inspiration for shape and draw three new motifs.

• Next pull inspiration for color and create two new color palettes.

• Create a new pattern from these new motifs and create two different colorways using your new palettes.

These sketches are derived from floral inspiration. Sometimes, the flower inspiration is a mere jumping-off point for creating abstract shapes.

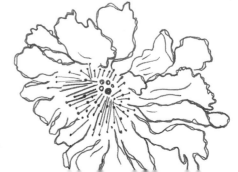

Flowers aren't just for a special occasion. I keep them in the studio as often as possible. Gorgeous bouquets provide endless inspiration for shape, style, mood, and interesting new color palettes. Bonus: They just make you happy!

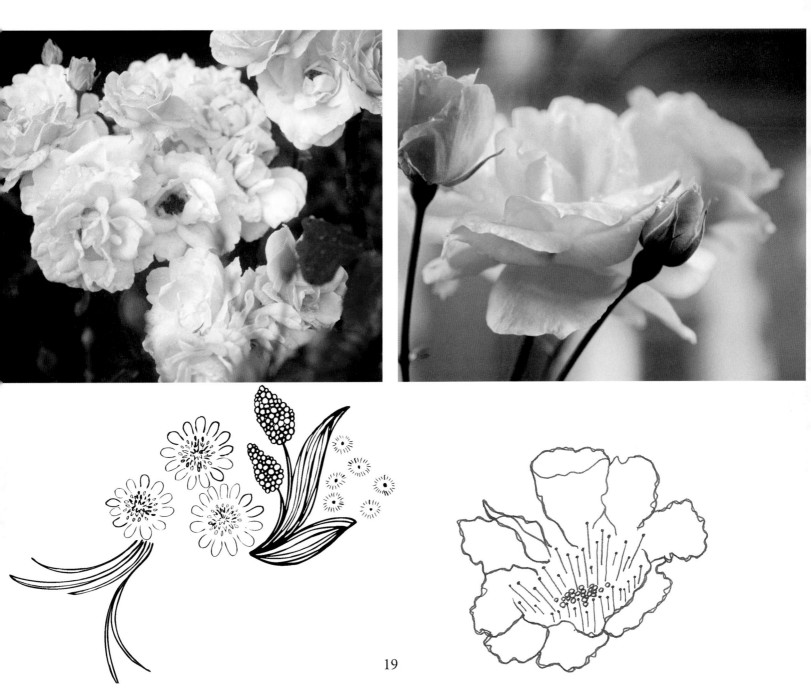

03

TAKE A WALK WITH YOUR SKETCHBOOK OR CAMERA

Want to get inspired? Time to vacate the studio! Sometimes, I get so involved in the day-to-day work that I have to remind myself to come up for air. Know the feeling? Luckily, there's an easy solution. Let's go outside! Too simple, you say? How is this going to help, you ask? First, it's really great for creativity to physically get moving. Often stepping away for a moment, taking a walk, and getting some fresh air can make all the difference. This time to let go a bit can actually clear the space in your mind for that next aha moment to happen.

When you head out, don't forget to take your sketchbook or camera, or both! Caution: Don't allow this to pressure you! Just because you have these things with you, doesn't mean you must use them. You just want to make sure you're prepared if something strikes your fancy along the way. Remember to go with your gut, not your mind. Snap anything that grabs you—color, shape, texture, and so on. If the walk is purely a few moments of clearing the mind and getting fresh air, that's perfect, too!

● *YOUR MISSION*

Get outside and explore! Collect images you love along the way.

*Things that seem mundane in everyday life will soon become little
bits that will spark a whole new pattern design or collection.
New ideas for color, shape, and juxtaposition of different styles can
come out of the simplest beginnings if we observe a bit more closely.*

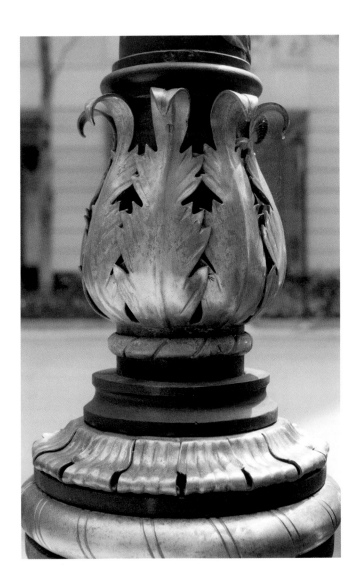

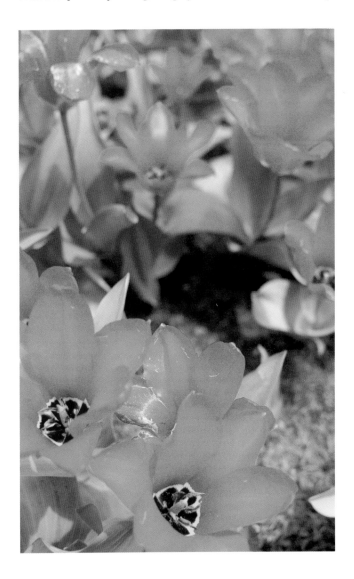

GATHERING INSPIRATION

04 SHOOT OR SKETCH TEN PATTERNS IN NATURE

I hope you're enjoying this time outside the studio. Are you starting to see the world with new eyes? I'll bet you're beginning to notice pattern in your world and life more and more.

● *YOUR MISSION*

Today, your mission is to find examples of pattern in nature. Capture ten images you see while exploring with either your camera or sketchbook or both!

In certain industries like home décor and contract design, the search is always on for the next "new neutral." Neutrals are important for many categories, and drawing fresh combinations from nature helps to keep them exciting.

05

SHOOT OR SKETCH TEN DIFFERENT TYPES OF FOLIAGE

Tired of drawing the same leaf shape again and again? An endless amount of inspiration for new foliage shapes is just outside your door! Perhaps you don't live in a tropical rain forest, but there are many varieties of vegetation to explore.

● *YOUR MISSION*

Grab your camera and head out on a hunt for ten different varieties of foliage. And then . . . draw them! *Voilà!* Ten new foliage motifs to add to your designs.

TIP

Don't forget to look at the details. You can find interesting patterns when you look even more closely at the veins of the foliage.

06

TAKE A TRIP JUST FOR INSPIRATION

Sometimes, you just have to go—a bit farther. Travel is one of my biggest sources of inspiration. I believe that seeing things we've never seen, eating things we've never eaten, and meeting people with different points of view on life all work to make us better creatives. Yes, of course we travel with our eyes. That's a given. However, I like to think of traveling with all my senses. The smells, the music, the food, and the textures all work to create a feeling you can weave into the story of your next collection. Magical, right?

For me it's vital to honor the importance of these journeys by not rolling them into travel for other purposes. You are a creative person and perhaps a business owner. These trips are invaluable for your development on both of these planes. However, if you just happen to be traveling to Buenos Aires for your cousin's wedding, then of course you will have your sketchbook and camera in hand as well and take advantage of the trip. I invite you to also create the space in your life and budget to take a trip that is purely to nurture your creativity, curiosity, and your soul.
Bon voyage!

● *YOUR MISSION*

Plan your next getaway. Just do it! Within the next calendar year, you can make it happen to visit a place that inspires you to tap into the deep well of creativity. You don't have to go to the other side of the world. You don't even have to go to the airport. Get in the car and drive somewhere new, if that's more accessible for you.

Whatever you do, be sure to commit to at least one overnight stay. Day trips are great, but this trip is meant to be a complete departure from your day-to-day routine so that you can immerse yourself in all there is to see in your destination of choice.

The resurgence of attractive street art is a great place to hunt for inspiration. These examples found in Atlanta are amazing pieces for their use of pattern, color, layering, and depth.

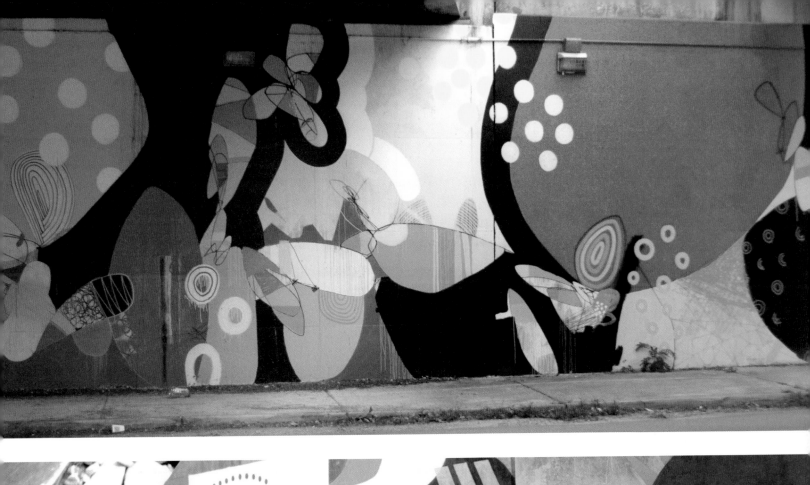
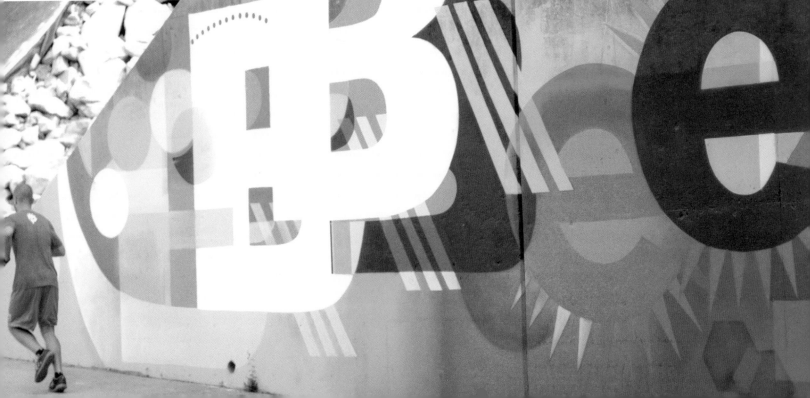

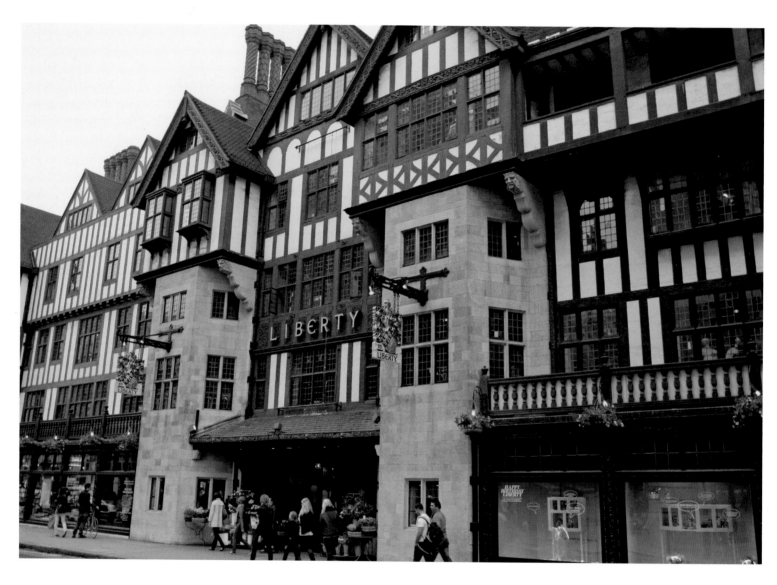

*(Above) The façade of Liberty of London, London, UK;
(right) Colorful stripes in the Notting Hill area of London, a great example of color and pattern;
(far right) Doors photographed in Paris provide inspiration for geometric shapes and color.*

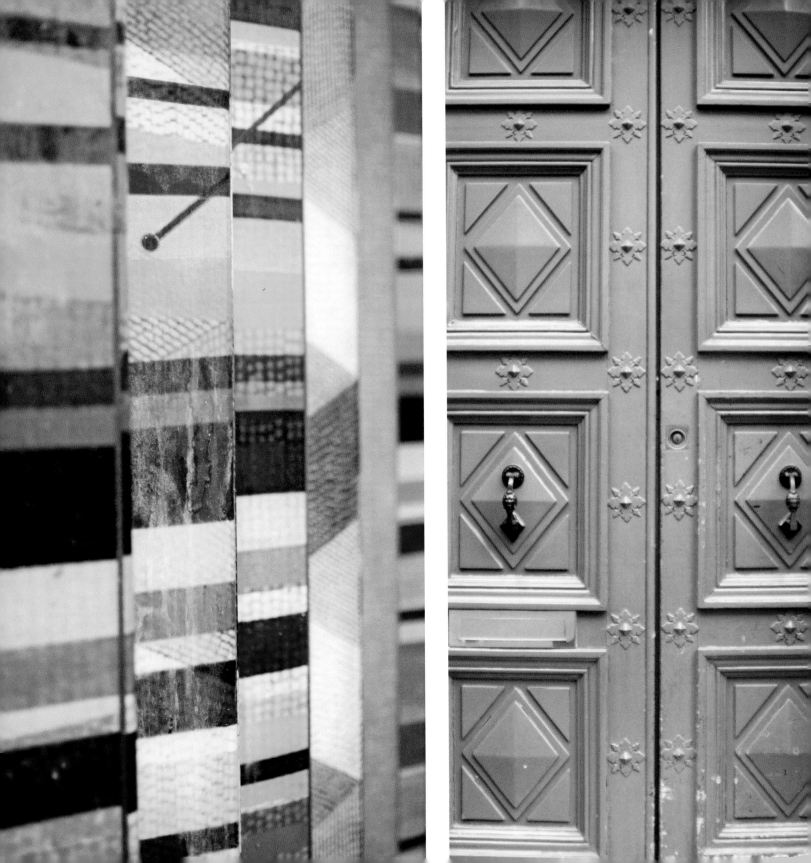

Jessica Swift

Jessica Swift, a full-time artist, surface pattern designer, and writer, is on a quest to inspire creative people everywhere to pursue their wild and colorful dreams ... and never give up.

Her magically uplifting, colorful artwork is licensed widely for iPhone cases, fabric, stationery, rugs, and more. Her art and products are designed to serve as tokens of happiness—reminders that you need (and deserve) to feel good in your life.

You can find her colorfully creating and blogging online at JessicaSwift.com.

Through a designer's eyes:

Three words to describe Jessica's work: colorful, magical, and uplifting.

If Jessica were a city: Cinque Terre, Italy— because it's an incredibly magical and colorful place, and you can't help but feel happy, uplifted, and inspired there.

Color obsession: Coral + fuchsia + charcoal gray.

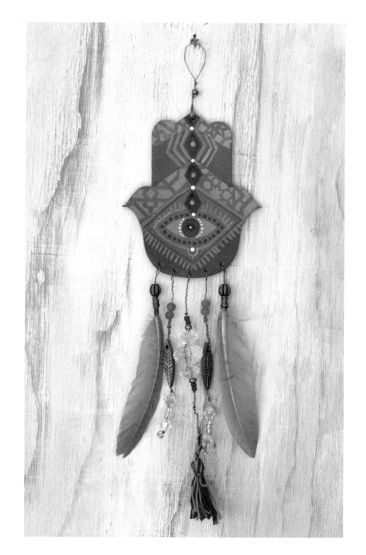

Jessica drew on the experience of her trip to not only create two-dimensional patterns but also incorporated patterns into this 3-D hamsa.

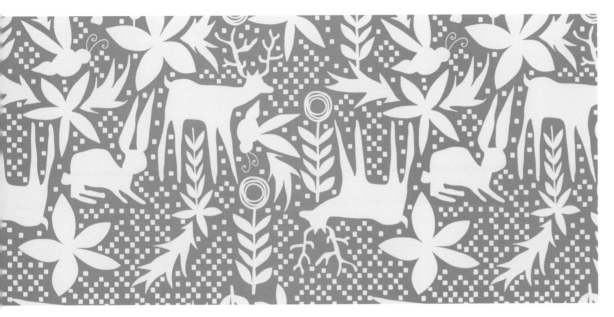

You can clearly see the inspiration of exotic animals, the vivid color use of the culture, and intricate tile work used in Moroccan architecture. Jessica has taken these influences and turned them into patterns that have her personal stamp in color, layout, and shape.

GATHERING INSPIRATION

07

INSPIRATION HUNT: GO "SHOPPING" FOR SAMPLES

I suspect my mother may think I have a bit of a spending problem. She sometimes calls me on a random day to say hello. She asks our standard, "Whatchadoin'?" I answer, "Oh, just doing a little shopping." What I really mean is I am out "shopping the market"—just seeing what's happening and what's new and exciting. I usually will pick up little bits of inspiration along the way.

My personal favorite places to shop are paper stores, retail fashion shops, retail home décor shops, and fabric stores. There are two reasons this is vital to my creative process. The first, of course, is obvious. These little excursions are loaded with visual candy and inspiration. The second reason is to be sure I understand what's happening with trends across different product categories. We won't touch too much on trends in this book, but I will leave you with one important snippet. Many of us who love creating patterns aspire to one day see those patterns adorn any variety of products, such as fabric, stationery, kitchen décor, and so on. If this is the case, I believe it's important for us to avoid creating in a vacuum. Understanding the market and market trends in design can help immensely if your end goal is to have your work be a part of that very market.

While you're shopping, do be sure to purchase samples you love. This doesn't have to be extremely costly. Grab a greeting card that makes you smile or a roll of gift wrap that speaks to you. Some fabric stores will even allow you to snip small swatches for free! Be sure to notice if there are any prevailing trends in color. Is everyone emphasizing pink on displays? Does everything have a bird on it? (Pun intended.) Make a mental note of these observations.

TIP

If it's already in the market, you're too late. I know—it just got tougher, right? Here's the trick. These trips are not meant for you to regurgitate what already is. Don't reinvent; innovate! Absorb what is so you can start to develop a sense of what's next!

● *YOUR MISSION*

Go shopping! Now that has a whole new meaning for you! Head out and shop the market and pick up inspiration samples that speak to you. Add them to your inspiration journal when you get home.

Keep your eyes open! The world is full of inspiration. Store displays are a great place to check out—not only for color, pattern, and shape, but also to get information on what the marketing teams think is hot and trending at the moment. Classic patterns like stripes, dots, plaids, herringbones, etc., will always be relevant. The challenge is to find new, exciting ways of expressing them as successfully exhibited with this stripe (at far right) found at Tricia Guild in London.

(Bottom left): At Liberty of London department store, the items within are a source of inspiration as is the magical atmosphere and creative displays.

GATHERING INSPIRATION

TIP

Don't fly through the museum gift shop. There are all kinds of treasures in museum gift shops. Loads of interesting, innovative, and often pattern-adorned bits of inspiration await you!

(Counter clockwise:) Love this painterly stripe pattern found in a museum in Europe; Victoria and Albert Museum, London, UK; a sample full of inspiration for color, shape, and folk motifs; Signage for the Musée d'Orsay, a beautiful work of art; Graphic posters can spark inspiration for geometric patterns.

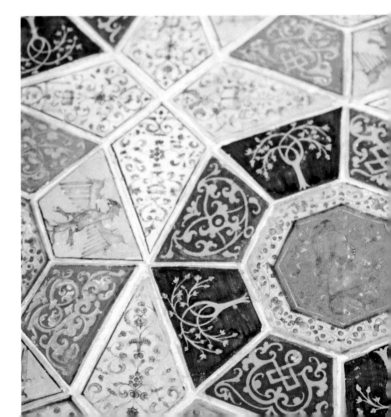

ency was
usion that
oting the
sparency, it
l.

view here,
ransparency
Nouvel's
t, in Paris,
tion of
space; and
acy and
hishunkan
City, Japan.
ch as
ugmented
ough
strating
political
ransparency

VISIT A MUSEUM, ART GALLERY, OR FESTIVAL

Obvious alert: Heading to museums and art galleries is always a great idea. The museum is one of my favorite places to go on a cold or rainy day. If it's been more than six months since you've been to an exhibit, put a date on your calendar today. Remember, you don't have to wait until you can visit the Met. Bloom where you're planted, as they say. Go to a museum or gallery near you. Been there a thousand times already? Bring your sketchbook this time and play.

Another great opportunity for inspiration is festivals and outdoor markets. Both afford you the chance to see new visual delights. They're even worth a day trip if there's nothing in your immediate area.

● *YOUR MISSION*

Head to a museum, festival, or open-air market. Don't forget your sketchbook and camera to capture all the amazing colors you're sure to see.

35

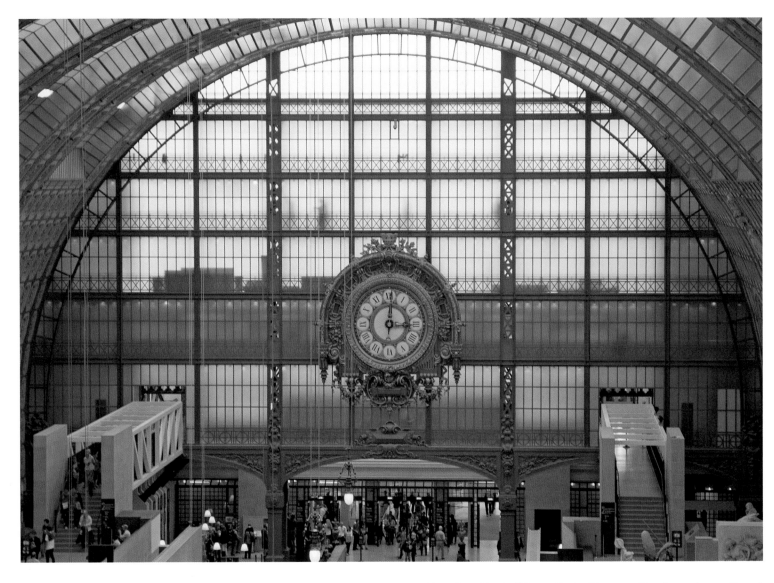

Shots from Musée d'Orsay, Paris: Photographing the art is not allowed, however, the architecture of this train station turned world-class museum is a visual delight on its own.

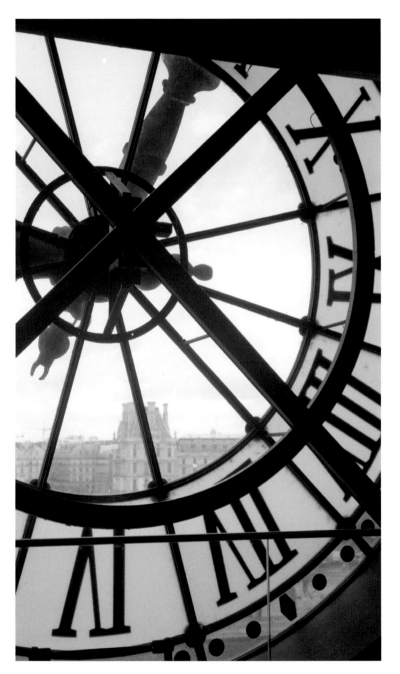

The museum is, of course, full of inspiration. Be sure to bring your sketchbook to be ready for when new and exciting ideas strike. Since many museums do not allow photos of the art, it is the perfect opportunity to get lost in the inspiration with basic pen and paper.

09

SHOOT OR SKETCH TEN
ARCHITECTURAL PATTERNS

Now that your eyes are wide open and you're investigating your world in a new way, let's continue to play! You just spent some time discovering patterns in nature. Now let's explore another subject that's a constant in your life: architecture. Don't worry—you don't have to live in New York or Paris to find gems of inspiration in the architecture around you. Look closely at iron gates and decorative cornices; even manholes may surprise you.

● *YOUR MISSION*

Take a stroll in a new neighborhood in your city and watch the treasures unfold. Don't forget your camera and sketchbook!

I love the pretty pastel façades found in London, UK. Inspiration does not have to be literal imagery of print and pattern. This image is striking to me because it inspires me to use color in unconventional ways.

Opposite page: Detail of an old tile floor. Cornerstones and entryways often have some beautiful pattern work. Pattern can be seen absolutely everywhere.

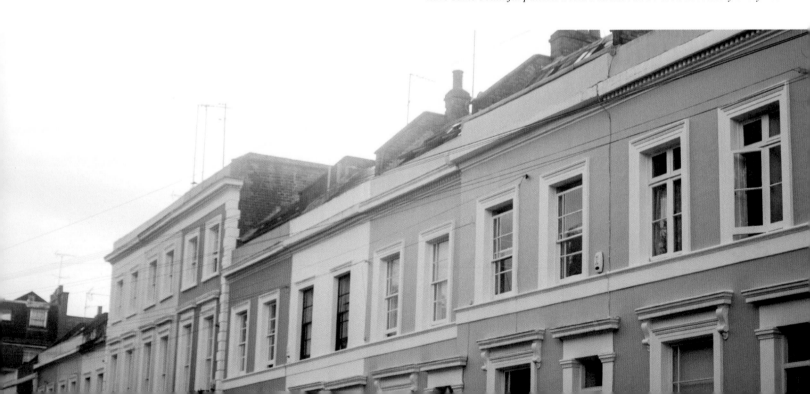

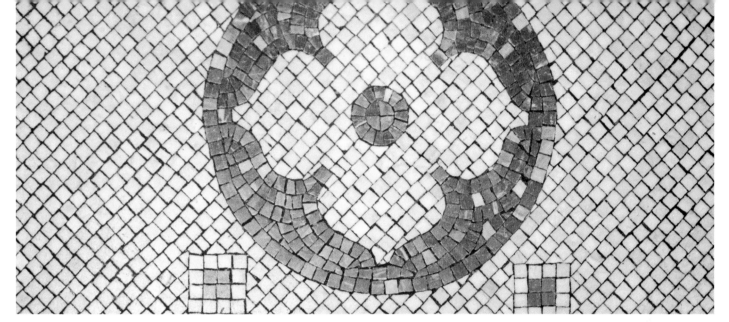

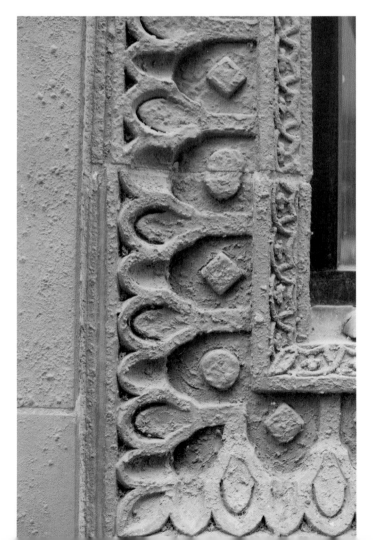

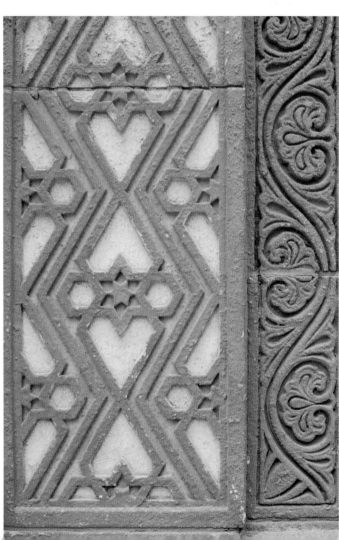

10

CREATE AN INSPIRATION BOARD

I love my online life. I love collecting digital images I find from all the corners of the world and fascinating events I cannot attend. However, for me there is nothing like actual tears, swatches, and samples I *can* touch. So much of the work of creating patterns is done on the screen, so it's nice to play in the tangible world for a bit.

There are many great ways to build fun inspiration boards. I've built several cork walls over the years, purchased bulletin boards, used cork tiles, and even used large blank canvases.

It's so important for me to have constant visual stimulation in my creative space.

My inspiration board is also the place where I collect and curate the images that inspire future pattern collections.

On the following pages, we will meet Mary Beth Freet of Pink Light Design. She is a master at creating deeply inspiring inspiration boards that clearly convey the mood she is looking for in her collections.

● *YOUR MISSION*

Create an inspiration board that has a central theme and inspires the feeling of a collection you want to create.

TIP

Use pushpins or some other removable method of affixing your images. You're likely to change your mind along the way.

I must always have a place to collect my images. This is a snippet from the large cork wall we built for the studio. You can see how my inspiration boards use color as a strong common thread.

11

CREATE A PINTEREST ACCOUNT

What did we do before Pinterest? If you don't use it, create an account now, seriously, go. Pinterest is an invaluable tool that allows you to collect and organize (into groups called boards) all those enticing images you find on the web. The best thing Pinterest ever did for creatives was introduce private boards. I love using private boards to collect inspiration images for new collections. For example, I am very inspired by fashion. Maybe, one day, I'll be front row for the shows of all my favorite designers and capture all my favorite pieces myself. Until then, I constantly review the shows and collect the images online with Pinterest.

● *YOUR MISSION*

• Open a Pinterest account today. If you already have an account, organize your boards with pattern creation in mind. For example, maybe you will have a board for inspiration for floral patterns and another for geometric patterns.

• When you're ready, create a couple of private boards where you can keep digital inspiration images for the collections you would like to create.

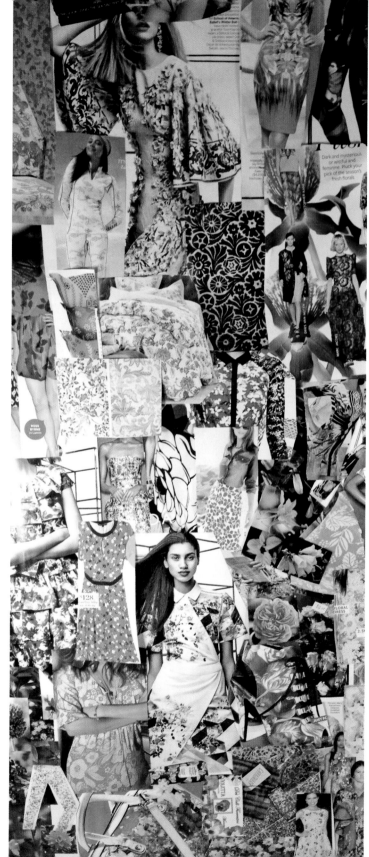

Mary Beth Freet

Mary Beth Freet is the agent and creative director of Pink Light Studio. You can find her work and the work of her artists in Target, The Land of Nod, HomeGoods, Barnes & Noble, and more stores. I've also had the pleasure of working with her during our days designing at Nordstrom. She has an incredible talent for inspiring her group of artists to create stunning collections through, among other tools, her wonderful inspiration boards. The boards she creates really give you a sense of the feeling she's looking for.

Through a designer's eyes:

Three words to describe Mary Beth's work: whimsical, bright, and happy.

If Mary Beth were a city: New York because I am constantly busy, filled with creativity, and open to possibilities.

Color obsession: a super-light, greenish-blue that reminds me of the ocean.

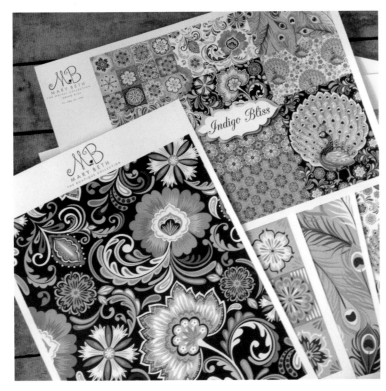

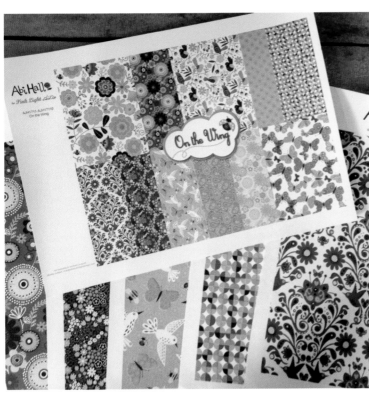

Mary Beth Freet of Pink Light Studio creates these inspiration boards for her team of artists, collecting images to initiate very clear direction for color and motif.

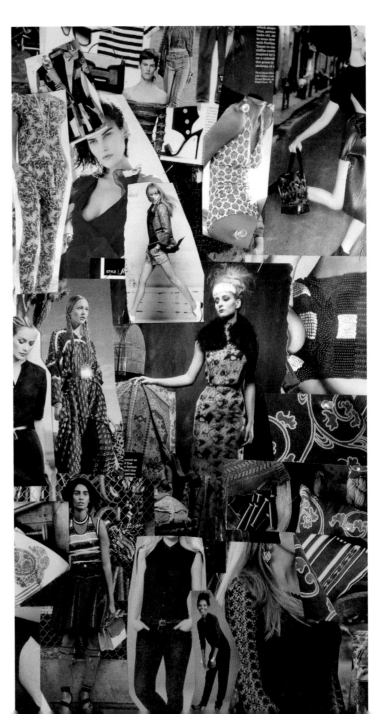

12

GATHER COLOR INSPIRATION

Every designer has a different method by which the story of their artwork develops. For me, color is the central part of the story. Many times, I have an idea for a color story and it will begin to unfold from there. This can happen for me even before the first motif is drawn. This is how vital a strong color story is in my mind and in my creative process. Color is really everything. It's tied to every consumer decision we make. The same collection with all the same designs will look totally different in different color palettes. So where do you start?

I love playing with color stories in a tangible manner first as opposed to on-screen in a design program. There are two ways I like to do this:

1. Collect tears, samples, and swatches purely for color. I shift them around and add and subtract pieces to create a color palette that works for me.

2. Use standardized color systems and books to play with different color combinations. Pantone and Scotdic are a couple of the leaders in the color space. They make a variety of great tools that you can purchase to work with color. These are a great way to start, because once you reach the point of transforming your patterns onto product, the colors are communicated to manufacturers with standard Pantone or Scotdic numbers so everyone is speaking the same language.

I like to start playing with these combinations on a white surface. Then, I also like to make sure the colors will truly work with each other on different ground colors as well. Be sure to play with the swatches and tears in combination physically on one another. It's important that the colors will be able to sit with each other in different combinations to round out a collection.

● *YOUR MISSION*

- Play with color! Pull tears, use fabric swatches or your favorite art medium, or use whatever makes sense for you.

- Develop a palette that's entirely new for you. Then investigate the Pantone website if you're unfamiliar with their range of products for designers.

I like using solid-color fabric swatches. The final color palette was created from various inspiration and exploring different combos. Be open to lots of trial and error during this process.

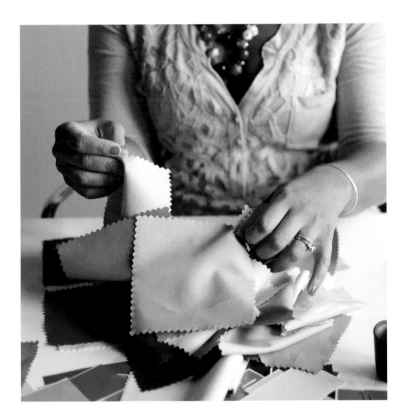

GATHERING INSPIRATION

EXPLORING MOTIFS

All patterns are built on a combination of motifs. A pattern may contain small or large motifs, many varied motifs or one singular motif, motifs that tell a story, motifs that are abstract, and so on. As you can see, there are endless possibilities. Your selection and creation of motifs in your patterns is often among the first steps in creating a new design and is just as important as color. Your motifs will help tell the story, set the mood, and evoke the feeling you wish to convey to the viewer or consumer of your pattern. As you begin working on your motifs as the building blocks of your eventual patterns, you will refine and finesse them many times over. Often, for me, once the motifs and the colors are set just right, the pattern-making process really begins to flow.

In this section, let's explore many different types of conventional motifs, from ethnic motifs all the way to children's motifs and everything in between. This will help to get you acquainted with the terminology and anatomy of patterns. These descriptions are also used in a variety of other design disciplines, so they will serve you well.

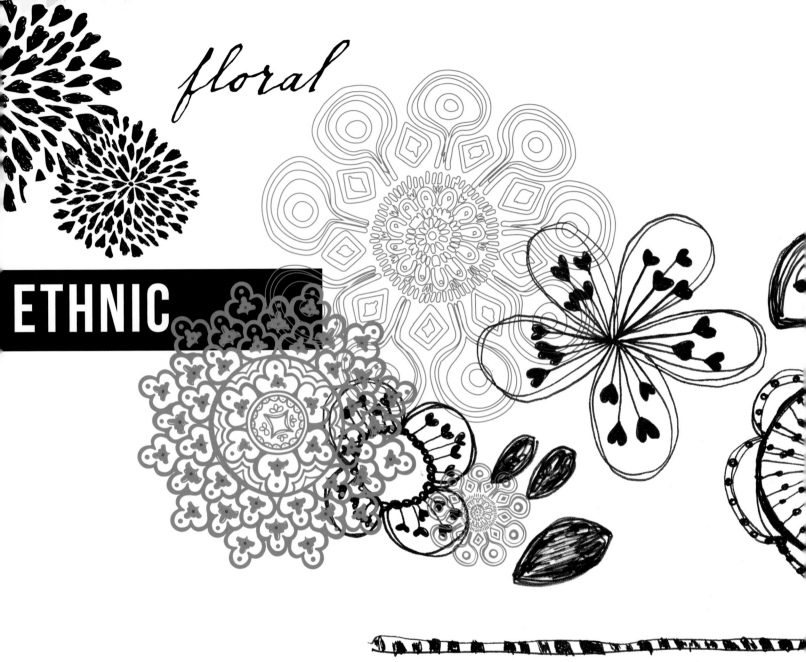

floral

ETHNIC

doodle

13

CREATE GEOMETRIC MOTIFS

Geometric patterns are composed of motifs that use simple shapes such as lines, circles, triangles, polygons, or simple organic shapes in a consistent and predictable manner. Geometric patterns have been used for decorative purposes in architecture, clothing, and more for many millennia across cultures. They are fascinating to me because they're so familiar to us, yet, when done well, they can be rather innovative.

Geometrics can be very orderly, as you would suspect. Design programs, such as Adobe Illustrator, are great for creating very exact geometric motifs. Within these programs, you can then create exactly placed, evenly spaced designs. I am also very intrigued by geometric patterns that have a more organic feel. This look is accomplished by creating the motifs in a looser, less perfect manner. This can be done by hand drawing the motifs or by spacing the motifs in a more random yet still orderly way.

● *YOUR MISSION*

- Try drawing both exact and organic geometric shapes. Do so with your choice of medium—digital, pen and paper, paint, or whatever medium you enjoy.

- Next, organize these motifs into a geometric pattern. Do so by placing them at specified distances from one another and continue to repeat. If you would like your pattern to feel more organic, vary the distance and even the orientation between your motifs.

Following are some examples to get you started.

Geometric patterns are great for application on products as they can easily execute as gender neutral, depending on the color used.

These designs stick to the rule that geometric motifs are composed of shapes and/or lines. However, they feel a bit more organic because none of the shapes are perfect circles. The layout of the pattern, with uneven, overlapping spacing, also aids in the more organic feel.

(Opposite) These pillows designed by Leah Duncan feature great examples of organic geometric patterns.

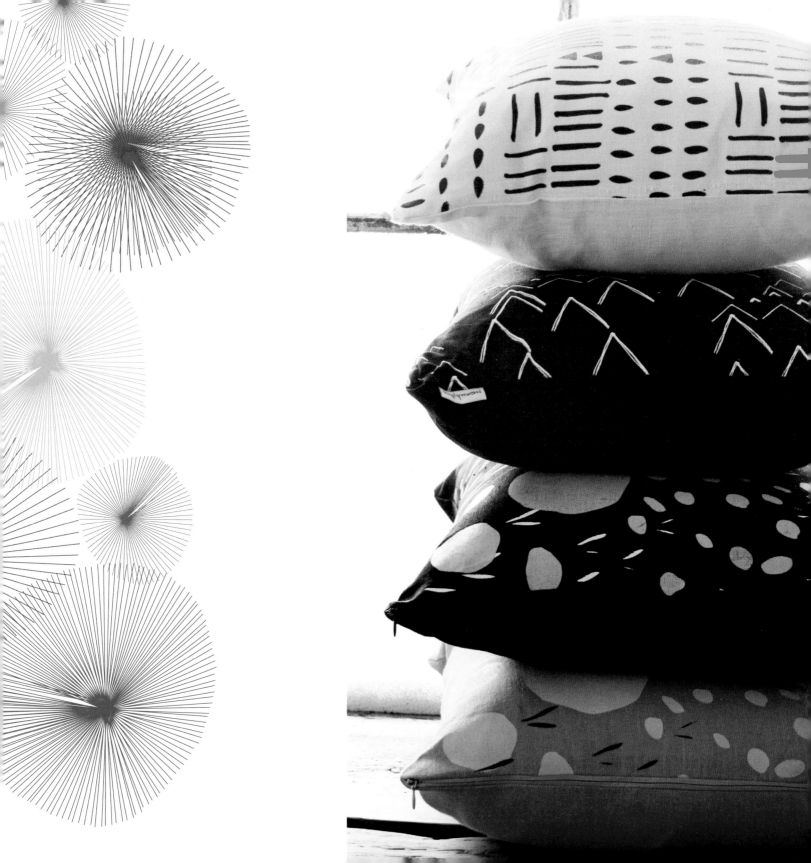

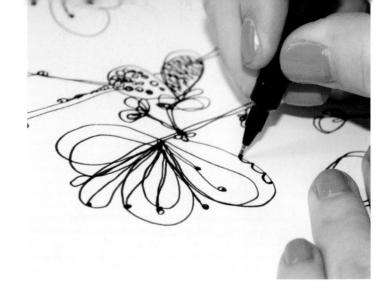

14 PLAY WITH DOODLE MOTIFS

We've all done it since we were young. Whether or not we were destined to be artists, we've been encouraged as children to doodle. It's so freeing. It allows us to daydream without any fear of judgment. It's a means by which to truly escape into our imagination. Doodling can even be a great form of meditation as we allow the whole world to melt away for a few moments. For all these reasons patterns and artwork created in a doodle style can feel very familiar and captivating. These patterns are playful and childlike, yet when done with skill, they can have an abstract sophistication, as well. With so many different ways to execute this look, the style can easily work in a variety of applications.

Rachael Taylor is one of the masters of this look. Over the next few pages, we will take a look at her unique style of doodling, her process, and the finished look on product.

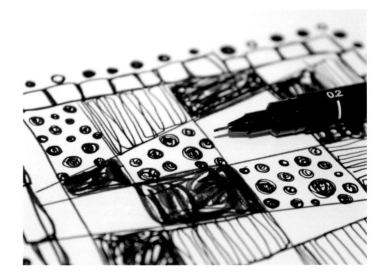

● *YOUR MISSION*

- Get excited. Get out your paper, crayons, markers, pencils, whatever your favorite tools are, and doodle away. Be free and don't think too much about it. One of the hallmarks of great doodle patterns is a high number of motifs. Create ten new doodle motifs.

- Then create a new doodle pattern using your new motifs.

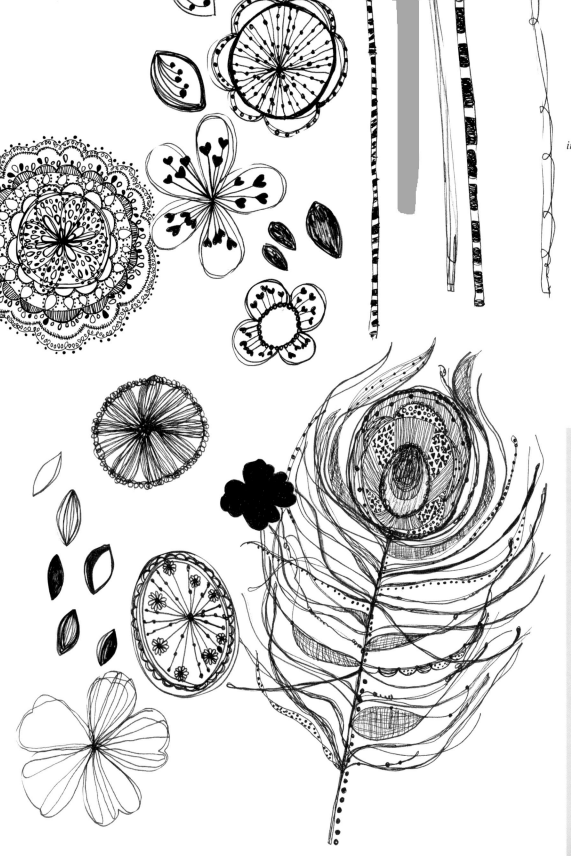

Rachael Taylor doodles are often based on organic shapes. You can clearly see the floral/plant/foliage inspiration. She then adds her sense of whimsy with hearts, dots, and other motifs.

TIP

You don't have to use all the motifs you created. Remember to step back from your design and have a look from a different perspective. Maybe three or four motifs will do just great!

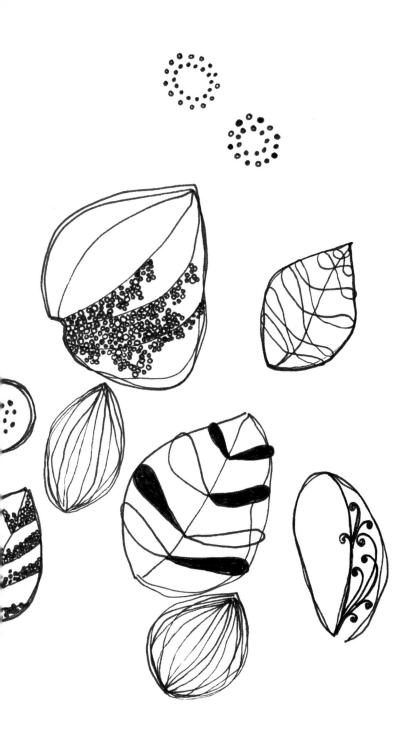

Here, we can see a pattern develop from sketches to repeat pattern to application on product.

Rachael uses her distinct style of line work to create a fresh take on doodles of foliage and florals.

EXPLORING MOTIFS

Rachael Taylor

Meet Rachael Taylor. She's a fun designer, illustrator, author, and teacher with several years of industry experience in a variety of fields. She is the founder of *MOYO* magazine and the very popular online course, The Art and Business of Surface Pattern Design. In my eyes, she is the queen of fun, quirky doodle art!

Through a designer's eyes:

Three words to describe Rachael's work: spontaneous, fun & happy.

If Rachael were a city: Liverpool, UK because it is eclectic, playful and friendly.

Color obsession: Bright teal, lime greens and more masculine palettes.

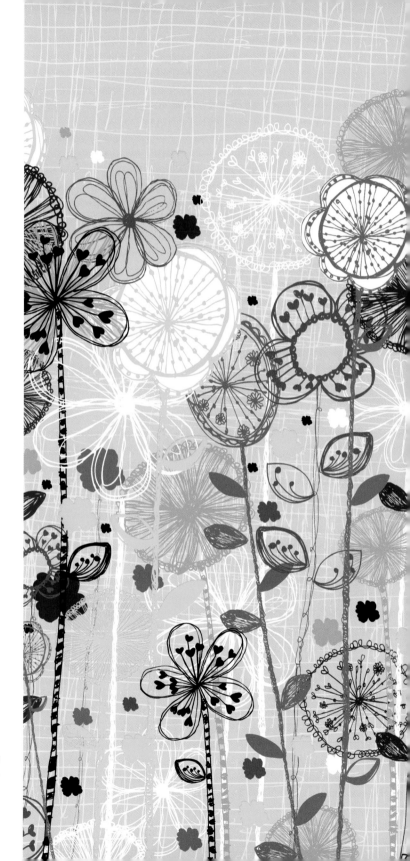

Rachael develops her doodle motifs into patterns and graphics for a large range of products.

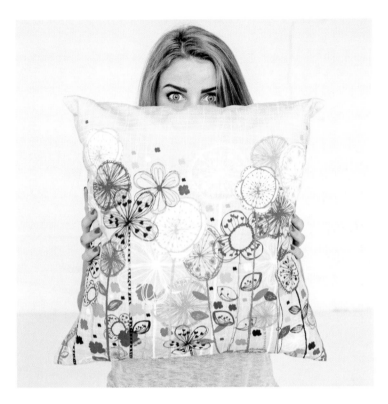

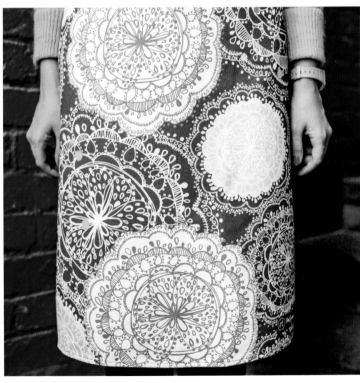

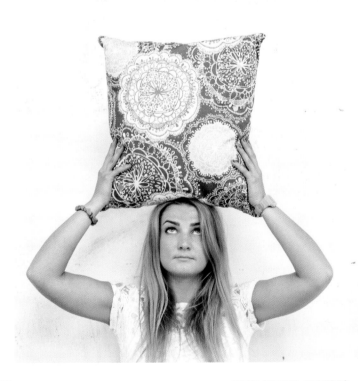

57

15

SKETCH FLORAL MOTIFS

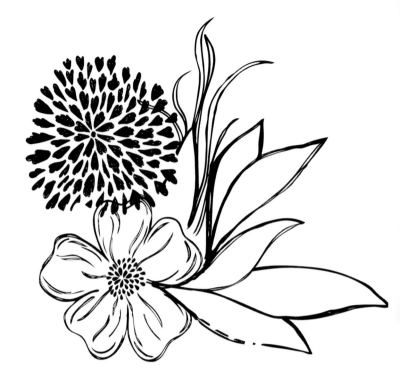

Flowers may be the one motif that most people can identify with. We've all had a floral print in our lives in some way. Maybe a certain floral print reminds you of the apron your grandmother used to wear or your favorite bedding as a child.

Historically, the beauty and intrigue of flowers have been expressed in many ways, and today there's truly no limit to executing floral motifs, which have become more stylized and creative.

● *YOUR MISSION*

Choose a flower and explore three different ways to draw it. The ability to achieve a wide range of styles in your pattern designs will allow you to express a variety of looks and feelings. This exercise will also help build the arsenal of skills you'll need to create depth in your designs by layering various styles.

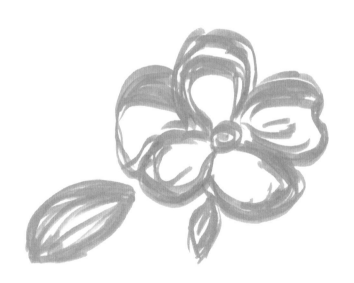

I created these floral motifs using a variety of line widths, weights, and styles.

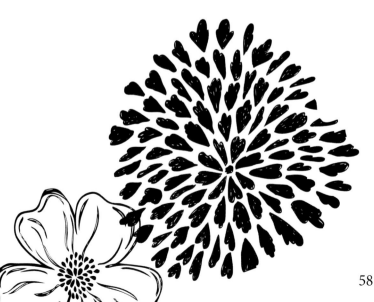

58

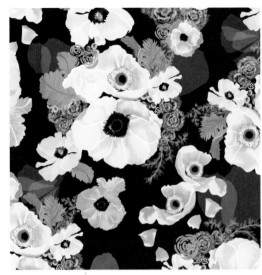

(Left to right) This graphic and loose-line work floral has lots of movement. Again, very graphic, this floral is a more abstract interpretation of a flower shape. This floral pattern has a more realistic feeling with details, depth, colors, and true-to-life shapes.

This is a great example of how different techniques—in this instance watercolor—can create an entirely different mood of floral. This one feels more sweet and romantic than the graphic examples above.

EXPLORING MOTIFS

16

REINVENT FOLK MOTIFS

Folk art is generally characterized as art created by the people. It differs from fine art in that it is, historically, created by untrained, everyday people (also called naïve art). The art is often reflective of the traditional culture and used for decorative purposes in everyday life as well as at festivals and gatherings. The motifs usually give you an instant feeling of place. An example of such a motif is the birds often seen in Scandinavian art and design. It's not only the motifs that can give this sense of traditional cultures, but also the drawing style, line quality, and even color palettes. Sticking with the Scandinavian example, observe the clean line style and bold color blocking that serve to illuminate the modern feel of this folk style.

Other examples of folk motifs can be found in Bavarian decorative arts, Eastern European arts, and so on.

● *YOUR MISSION*

Explore using folk styles to inspire you to create something new. Try these ideas:

- Draw three motifs that replicate the clean Dutch line style, but create new shapes for the motifs.

- Now use a traditional shape like the clean-lined, simple tulip, but fill it with a simple pattern to give it a new feeling.

- Use your motifs to create a simple, clean, linear pattern in the same vein.

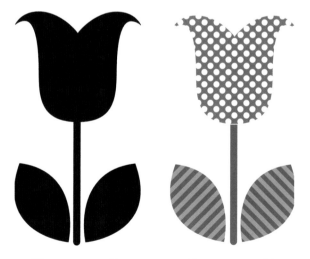

Practice being inspired by traditional folk motifs, but transform them to make them your own and new! Notice that in these examples, the use of color is very different. Elizabeth Olwen is known for her vintage-inspired, washed palettes, the color choices of Ana Davis (right) can feel quite feminine and sweet. However, the "folk" feeling is very clear through the motifs.

Ethnic motifs such as this medallion inspired by Moorish architecture and the camel (page 62) can be used to create ethnic prints like these. The patterns can use direct references or loosely resemble iconic motifs that give a sense of culture and place, such as a Greek key.

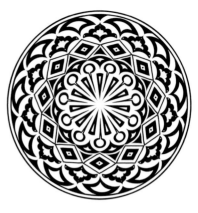

17 EXPLORE ETHNIC MOTIFS

Ethnic motifs have been an exciting design trend for years now. They feel organic, comforting, dynamic, and somehow familiar. Perhaps this is because ethnic motifs are a part of our collective human history.

The dictionary defines the word *ethnic* as relating to or characteristic of a human group having racial, religious, linguistic, and certain other traits in common. Thus, ethnic motifs, similar to folk motifs, are designs, shapes, and colors that are representative of the cultures of groups of people. Wherever people go, they take these ethnic traditions with them. A great example is the beautiful tile designs in Morocco and other parts of North Africa. They are stunning and forever linked to the people who created them and who use them as decoration in their spaces. You will, however, also find these gorgeous tile designs in parts of Spain from the time the Moors inhabited the area. The design tradition and the people are linked.

Many traditional dyeing techniques popular today, like ikat and shibori, can be re-created digitally with beautiful results.

● *YOUR MISSION*

Draw three sets of ethnic-inspired motifs. Then create an ethnic-inspired pattern using one of these sets of motifs. Color your ethnic-inspired pattern new by using a modern color palette to complete the print.

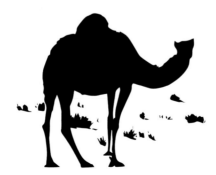

(Top) Motif inspired by Moorish architecture in Spain and North Africa; (right) Motif inspired by the African desert

18

DESIGN A FOULARD

Originally, the term *foulard* referred to the actual type of fabric, soft and lightweight silk, that's used in the making of handkerchiefs. Today, we use the word foulard to refer to the small-scale pattern with a basic repeat commonly found on scarves and men's ties and robes. Due to this end use, foulard color palettes were often deep tones of blues, reds, and greens. Now you see foulard-inspired prints in a variety of colors and even in larger scales, depending on current trends. The use of these prints has expanded to a variety of product categories, including home décor and wall coverings.

● *YOUR MISSION*

• Create a foulard pattern with a traditional color palette of blues, reds, greens, and gold.

• Then create a foulard pattern with a modern color palette.

⅓" (8 MM) MOTIF

Here, you can see the standard size of a foulard motif.

19

PLAY WITH CHILDREN'S MOTIFS

During my time as an artist at Nordstrom, I worked in the Kids' Wear product development area on textile art for a huge range of programs, from Layette all the way up to Big Girl and Big Boy (which are slightly smaller than Juniors). I had to develop my skills at drawing for these markets, and fast! In the same day, I was going from sweet, fat cows for Baby to rad skaters for Big Boy. This was no small task. I got the job done and learned a lot, but I also learned that kids' patterns were neither my passion nor my strength. I have immense respect for artists who excel at kids' pattern design. Abi Hall is one of these truly gifted artists. Her work is full of whimsy, play, and pure joy. Over the next few pages, she will give us some insight into her world of sweet children's motifs. It takes a special hand to capture that childlike wonder and sweetness within a sophisticated, balanced design. Although this subject matter, at times, presented me with a steep learning curve, I never giggle so much as when I'm drawing children's motifs. How can you not have joy in your heart when you're drawing big, fat, round elephants?

TIP

The trick for creating successful children's patterns is to understand your audience. If you're creating a pattern aimed at newborn clothing or décor, think about the mindset of the customer. Sweet, sweet, sweet to the max will be the ticket here! Think about creating something that new parents and grandparents will love.

● *YOUR MISSION*

• Start by drawing animal motifs that have a baby look and feel. (If you get stuck on how to make them feel young, make them round and fat or enlarge their heads, then work to develop a signature style of your own.)

• Draw a few animal motifs that have a playful kids' feel but that aren't babyish.

• Practice drawing three youthful motifs, such as a kite, a hot-air balloon, or toys like rattles. Use your new motifs to create a children's pattern.

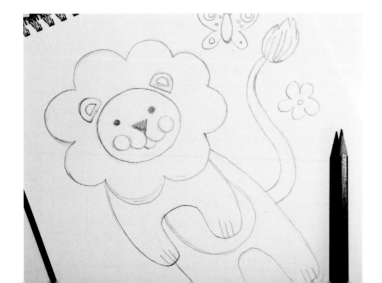

A quick pencil sketch of a children's character that Abi will later scan and redraw in Adobe Illustrator.

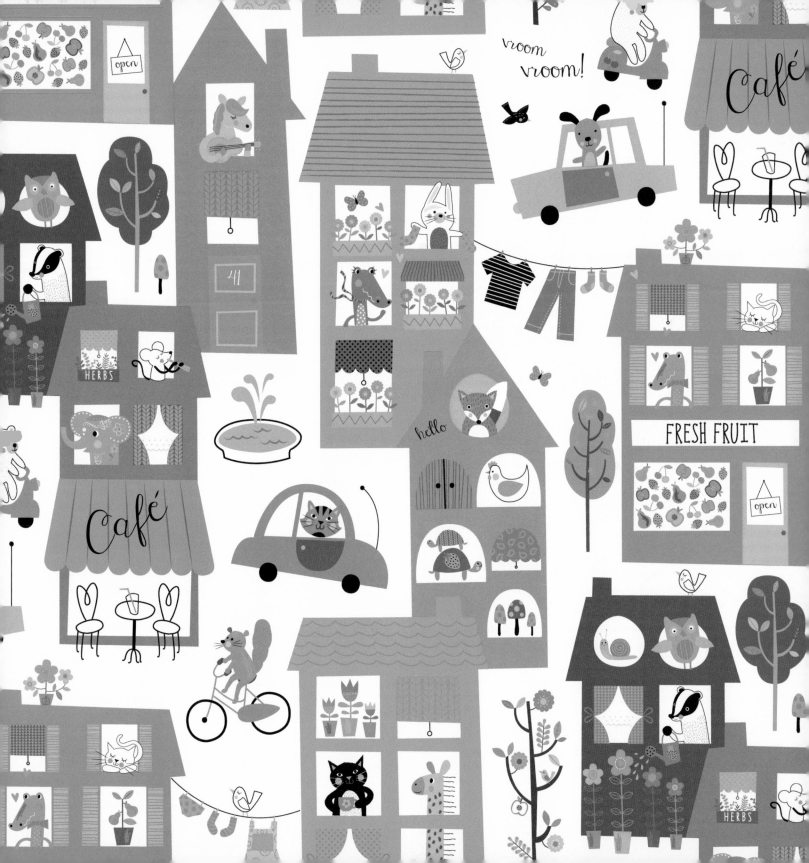

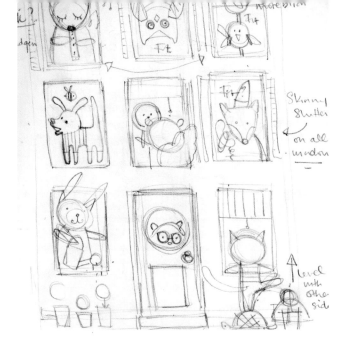

Abi Hall

Abi is a printmaker, pattern designer, and illustrator living in Ireland. She has a gift for expertly capturing the whimsy, innocence, and pure fun of a child's imagination. Here are some tips from Abi on creating children's work that really hits the mark. The steps showing Abi's process and directional were photographed by Abi herself.

"I like to keep the forms of my characters quite simple and really concentrate on making sure that they are expressing a lively personality. I create uncomplicated, rounded, and slightly exaggerated shapes and use these in combination with exciting color combinations to appeal to a child's imagination. I love to create for children, as I can really let my imagination run wild in the design process and tell fun, fanciful, and exciting stories throughout a pattern. In this way, I hope to really engage children, and encourage them to develop a narrative to go along with the visual elements. I like to think that a child looking at my Happy Town pattern will wonder what song the horse is playing on his guitar, and what his name is, and who lives downstairs from him."

Through a designer's eyes:

Three words to describe Abi's work: vibrant, fanciful, elegant.

If Abi were a city: Tokyo! It's bright and graphic and fun and a little weird.

Color obsession: I have an ongoing obsession with the color pink. It's such a versatile and pleasing color to use. I'm currently crushing on sludgy pastel pinks with moss green and moody gray; and always love using super bright pops of cerise or coral against a navy blue or deep teal ground.

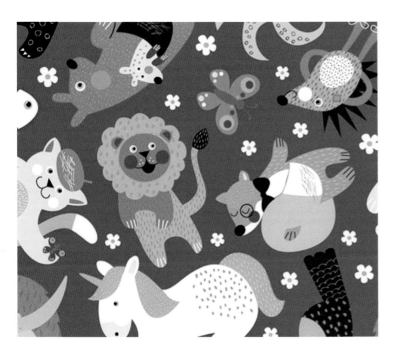

(Opposite) You can see Abi's sketch come to life in this playful children's pattern. (left, top) Abi's whimsical cast of characters is arranged in a playful children's pattern. (bottom) Abi's children's patterns adorn a variety of fun products including sewing fabrics as shown.

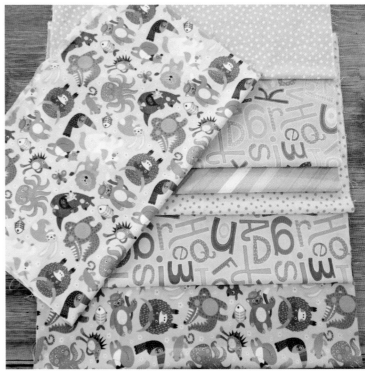

EXPLORING MOTIFS

20

CREATE CONVERSATIONAL MOTIFS

The term *conversational pattern* can be used to describe any pattern with motifs that are objects as opposed to abstract shapes. For example, a pattern that is composed of sunglasses, beach umbrellas, and bathing suits would be considered a conversational pattern. These types of prints are found across many different product categories, from pajamas to kitchen textiles to quilting fabrics. They are meant to be fun, are often lighthearted, and can tell a little story. Arrolynn Weiderhold is amazing at creating these fun stories with pattern and graphics. In the following pages, we will see her sketches developed into a pattern and then adorn product.

● *YOUR MISSION*

Jot down a list of themes that would make good conversational prints (such as nautical, travel, sports, etc.). Next to each theme, jot down at least three different ideas for motifs that could be part of the pattern. Then choose one of the themes and begin drawing the motifs. Create a conversational pattern from these motifs.

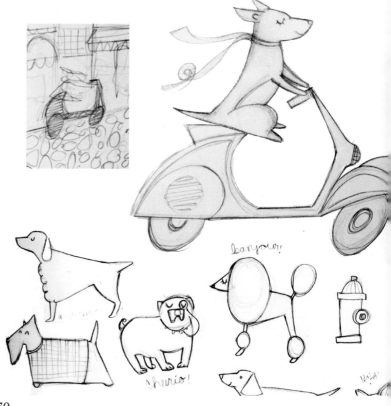

Arroylynn's friendly dogs from around the world with greetings and corresponding patterns.

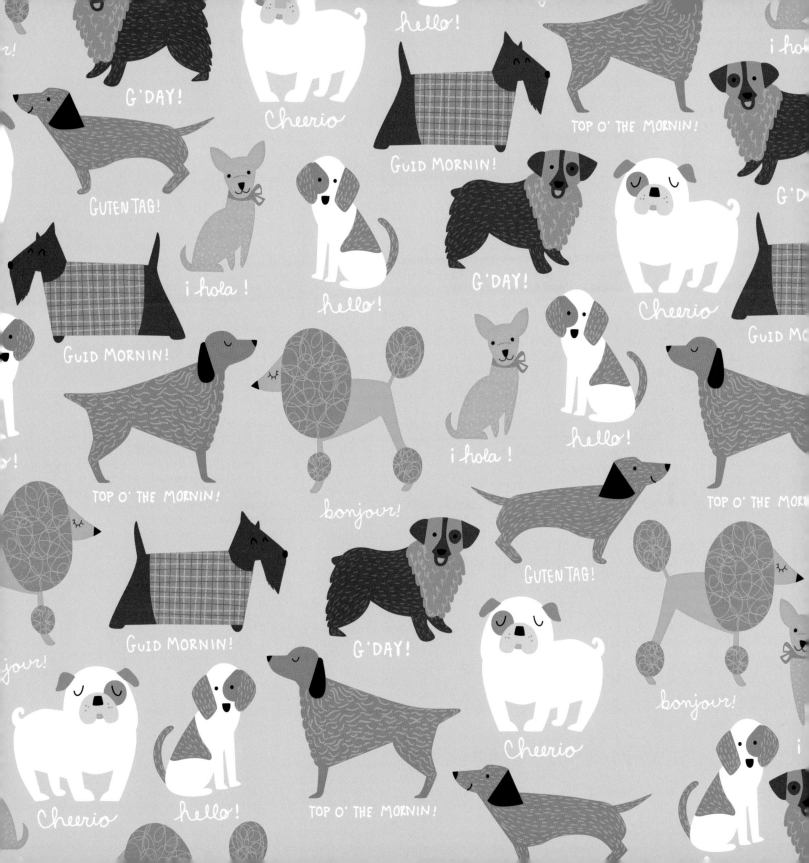

Arrolynn Weiderhold

Arrolynn is originally from Florida, where she received her BFA in illustration from Ringling College of Art and Design. She now resides in Redondo Beach, California, with her husband, and spends the day sketching, drinking coffee, and walking along the beach.

Through a designer's eyes:

Three words to describe Arrolynn's work: cute, fun, and happy.

If Arrolynn were a city: San Francisco—because there's a great mixture of colors, curves, and angles.

Color obsession: yellow, it's so bright and cheerful!

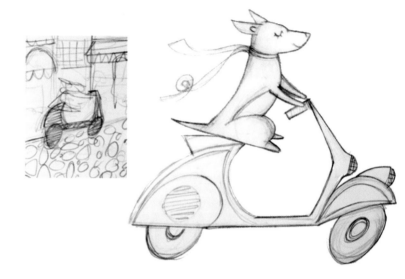

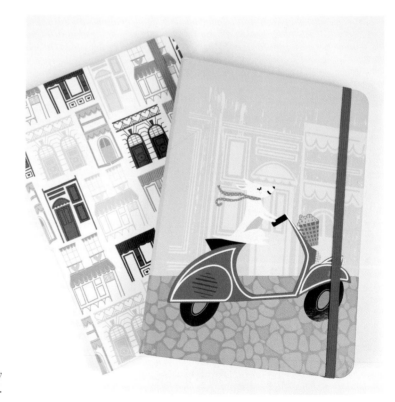

These are the pencil sketches for the Cultured Canines collection by Arrolynn Weiderhold.

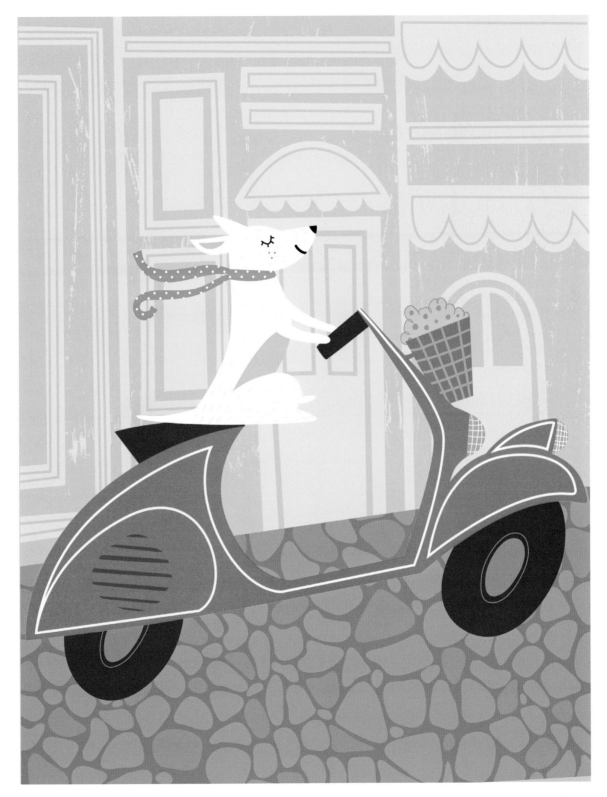

21

ADD TEXTURE TO MOTIFS

TIP

You can manipulate the color of your textures in Photoshop.

Using texture is a fantastic way to bring some life into a flat pattern. Texture is also a great tool for creating a feeling of depth in your design. Creating texture on both the ground and throughout the motifs of the pattern can help to give your design the feeling that it's actually living on a tactile surface like fabric or specialty paper. For example, you can trick the eye into the illusion that your pattern is on a woven ground. You can also use texture to give your pattern the illusion of originating via different techniques, such as stamping or block printing.

Mastering adding texture to your patterns takes finding/ creating the right tools, and knowing when to say when. The goal is to create a sense of an organic creation experience where the imperfections are totally perfect.

● *YOUR MISSION*

Create a texture for your patterns by scanning a material of your choice, cloth, specialty paper, or something else to use as a ground. Alternatively, you can purchase texture on sites like Shutterstock.com. Next, use a digital texture to create the effect of a stamped motif.

A bit of subtle texture adds depth and interest to this pattern.

COLOR + PATTERN

A digital texture can be used to create an interesting background for your pattern, or it can be used to give some texture to your motifs. Simply color the texture the same color as your ground color to create a textured motif.

22

CONVERT HAND-DRAWN MOTIFS TO DIGITAL

To produce the vast majority of patterns today, it's necessary to transform your hand-drawn or painted work into a digital format. This is the case whether you're working with a manufacturer to get your patterns onto their product or printing your own fabric through a resource like Spoonflower.

This process can seem very overwhelming, so let's walk through it step by step.

1. If you're drawing your motifs with pen and paper, it's in your best interest to use unlined, decent-quality drawing paper. This will give you less to clean up when you bring your design into the digital program.

2. If you're using a drawing program like Adobe Ideas or Adobe Line, you've saved yourself a step, as the sketch is already in a digital vector format and can sync with the Adobe Creative Cloud.

3. For your hand-drawn image, you will need access to a scanner. If you don't have one, you can have it scanned at your local copy shop. Just be sure to bring a USB drive or CD with you so they can save your image. Request that they scan your image at 300 dpi as a tif, jpg, or pdf file and with the anti-alias option unchecked. If your original is larger than the scanner bed, don't worry. You will just have to take multiple (overlapping) scans and tile them together in the design program of your choice.

4. Next, you will import your scans into your design program. Adobe Illustrator or Adobe Photoshop are the standards, but other programs are out there as well. In either program, you will likely need to clean up (maybe smooth out some lines, for example) your motifs before working them into a pattern.

 * Photoshop users, you will notice right away when you open your scan any stray marks on the page. If you had to tile images, you will bring the separate images into one file now. I like to smooth out the line work by either erasing stray marks or filling in a bit where necessary. Be sure to preserve the integrity of the original quality of the line work. This is part of what makes the hand drawing special! It's good to start with nice, clean line work so that your final pattern will appear crisp and polished. This will affect everything from color management to laying out your pattern due to the nature of how pixels work in this program. Take your time to clean up the image to your satisfaction.

 * Illustrator users, Illustrator has a genius tool called Live Trace that will instantly turn your drawing into a vector image. It's like magic! Even with this tool, it may be necessary to manipulate some of the vector points to smooth out the image.

 * Photoshop and Illustrator one-two punch!—Depending on how the image looks once I scan it, sometimes I like to combine both of these techniques. I will take the scan into Photoshop first to freely "draw" and smooth out any stray line work. Then I will live trace the image so that I can easily move and turn the motifs to create a pattern.

5. Once your scan is all cleaned up, you're free to move your motifs about your art board as you see fit to create your pattern.

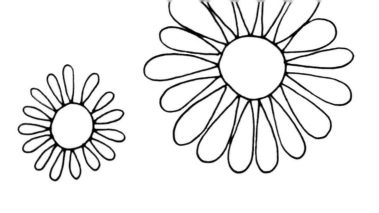

YOUR MISSION

- Develop some motifs by hand via the medium of your choice like pen and ink, painting, or even a digital drawing program.

- Next, practice scanning your work and cleaning it up for preparation to manipulate digitally. It's a good idea to print your motifs as you work on your scanning and cleaning techniques. Often, you will be able to see the imperfections more clearly on the hard printed copy than onscreen.

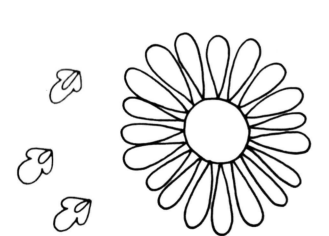

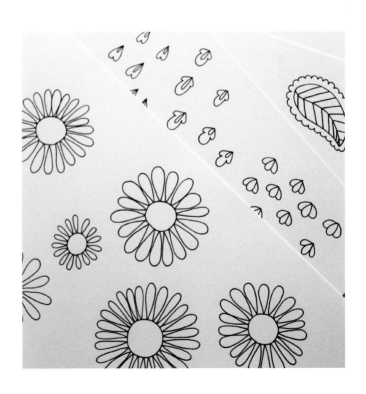

The flowers, leaf, and small embellishments will all be incorporated into my paisley damask repeat pattern. These were all created using micron pens on smooth Bristol board.

Jenean Morrison

Meet Jenean Morrison. She is brilliant at creating intricate, beautiful patterns. What's so amazing about her work is that it's so exacting and all originates by hand. Here's a bit of insight into her process.

When drawing for patterns, I rarely draw an entire scene or design that contains multiple graphics. I prefer to draw each element individually, then scan it in and combine it with other elements to create a larger image. In this design, the leaf, flowers, and decorative motifs were pulled from different sketches and combined with a paisley shape to form this damask-like pattern.

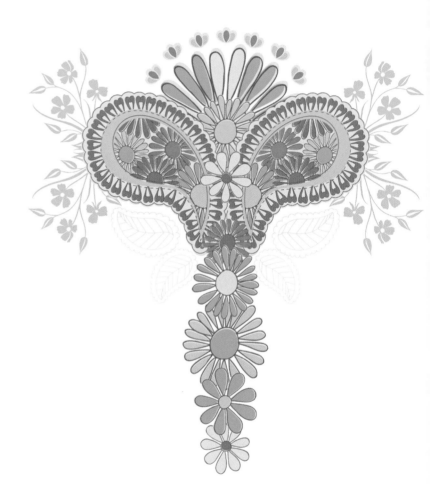

These individual sketches are then arranged and colored digitally to create one large motif that will be repeated to form the full pattern.

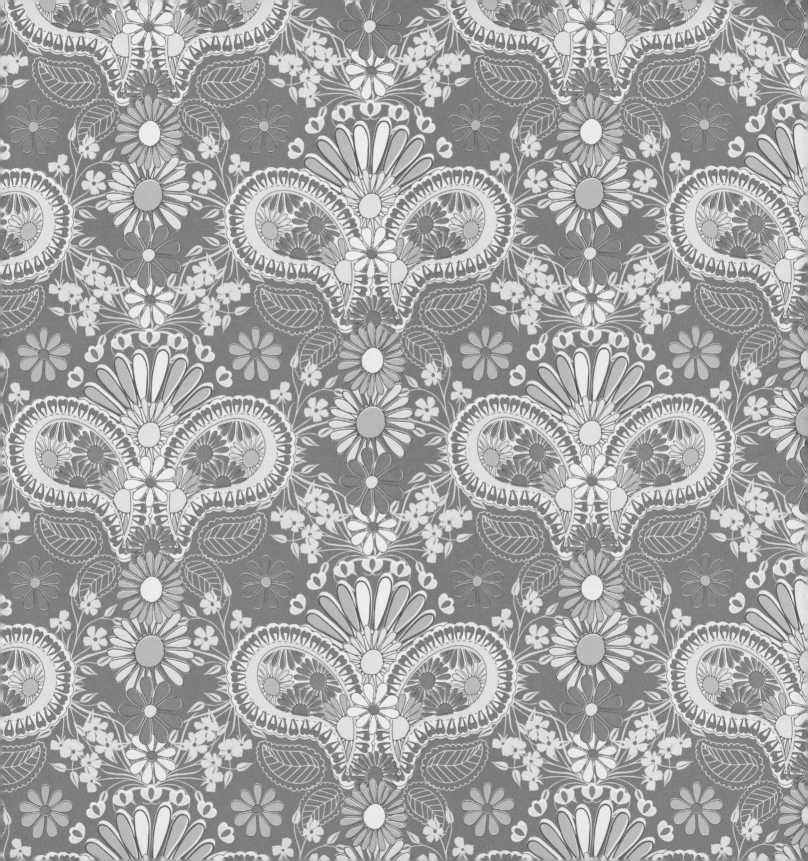

DESIGNING REPEATS

Here we are at the moment I am certain many of you have been waiting for. Time to dive into the anatomy and process of creating the actual repeat patterns! Why the wait? you may ask. For me, the technical part of creating the patterns is the easy part. Once you learn how to create patterns, the mystery will forever be unlocked for you. This section is so deep in the book because it's very important to understand that it's easy to repeat a motif over and over again and call it a pattern. All the work you've done thus far will help you to give your patterns a soul so that they're truly pieces of artwork that speak to the viewer and ultimately the consumer.

So let's dive in! Coming your way in this section are all the different kinds of repeats out there and how to execute them on your own.

*Pattern screen printed on fabric by Leah Duncan. You can see she
has created a repeat with lots of different combinations of these
simple motifs to give the illusion that it is not repeated.*

23 DESIGN A STRAIGHT REPEAT

A straight repeat is the most simple of all the repeats. It's probably what you instantly think of when you think of a pattern—a motif repeated over and over in a straight line. The motifs are evenly spaced. The most simple example of a pattern with a straight repeat is an even stripe. This is simply one band of color (one motif) repeated and evenly spaced. Of course, other patterns are composed of much more complex motifs or groups of motifs that are arranged in a straight repeat.

● *YOUR MISSION*

- I am sure by now you're in the full swing of noticing patterns everywhere you look. Find and collect five different patterns that use a straight repeat. Collect the samples you find or collect them by snapping a photo. Remember to look all around you in nature, architecture, food, fashion, and so on.

- Ready to give it a go? Now that you understand the anatomy of the straight repeat, create a simple pattern by hand that is a straight repeat. You can do this with a simple motif like a dot or star just for practice. Measure your spacing with a ruler and understand the motifs will not be identical, but you will create a nice, organic repeat pattern. Then, using the design program of your choice, create a pattern with a straight repeat.

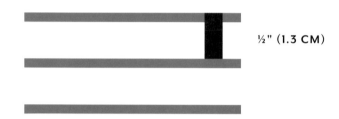

½" (1.3 CM)

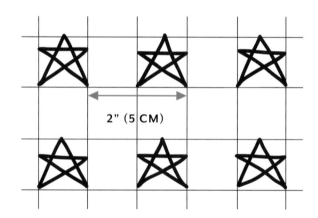

2" (5 CM)

Practice creating a hand-drawn straight repeat. Graph paper may come in handy for this exercise.

This is a simple vertical repeat demostrated by an even stripe. The distance from the original motif to where the motif repeats itself measures the size of the repeat. In this instance, it is a ½-inch (1.3 cm) repeat.

(Opposite page) Examples of patterns using a straight repeat

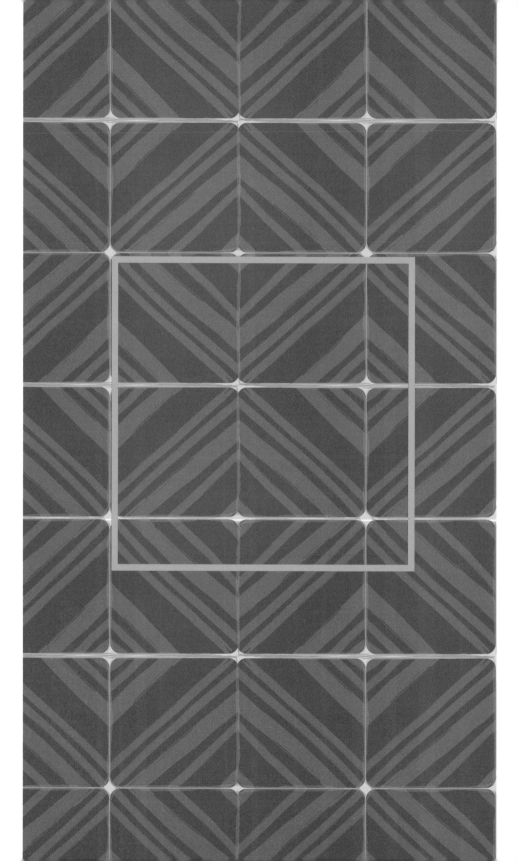

This is an example of a more complex repeat. It will be repeated horizontally and vertically end to end. The larger image shows a few repeats of the pattern. The box helps you see the original tile image above. With the box you can easily see how the pattern repeats itself.

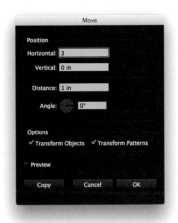

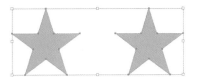
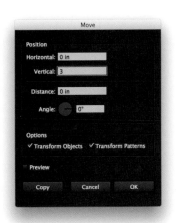
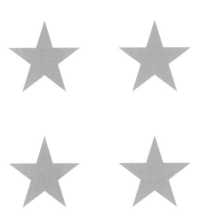

First, select your motif or cluster of motifs. Then, hit the Enter button on the keyboard and the Move tool will appear. Then, enter the desired amount you would like to move the item(s) vertically and horizontally. Finally, select copy from the same dialog box.

24

DESIGN A HALF-DROP REPEAT

TIP

Half-drop repeats are commonly found in fabrics, fashion, and gift wrap.

Personal opinion alert! Half drops are my favorite of all the repeats. This, of course, is totally subjective, and there is no right or wrong answer when you choose what kind of repeat pattern you would like to create. At the end of the day, you will choose the repeat that best serves the design you are creating.

Allow me a moment to try to sway you into my camp (wink wink). Half-drop repeats are my favorite because they create the feeling that you cannot tell where the repeat of the design begins and ends. I love this to be the case in my pattern designs because I am always striving for a very organic feeling. I do a lot of modern floral patterns in my work. I love for these patterns to feel as though they are one continuous design with no discernible repeat. I think it's more intriguing that way (again, there's no right or wrong here). This works for my style of work; however, I don't use it exclusively. I'll step off my soapbox now.

So what is a half-drop repeat and how do you achieve it? In the last exercise, we learned about straight repeats. To create the repeat, you moved your motif once by a specified amount horizontally. Now to create a half-drop repeat you will move your motif twice—one time horizontally and then one time vertically, half the distance of the horizontal move. It's simpler than it sounds!

YOUR MISSION

- Find and collect five examples of half-drop repeats.

- Using the method/medium of your choice, create a simple half-drop repeat with one motif.

- Using the method/medium of your choice, create a half-drop repeat with at least three motifs.

Below is an example:

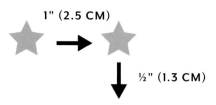

1" (2.5 CM)

1" (2.5 CM)

½" (1.3 CM)

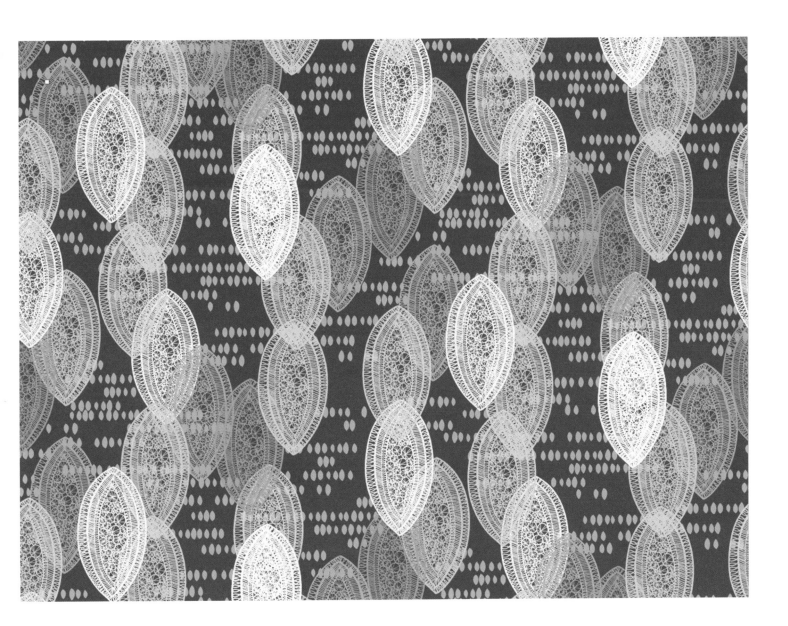

25 DESIGN A BRICK REPEAT

Brick repeats are common in textile and fabric design. Simply put, they're the horizontal version of the half-drop repeat. This time you will move your original motif a specified amount once vertically and then once horizontally half the distance of the vertical move.

● *YOUR MISSION*

- Using the method/medium of your choice, create a simple brick repeat with one motif.

- Using the method/medium of your choice, create a brick repeat with at least three motifs.

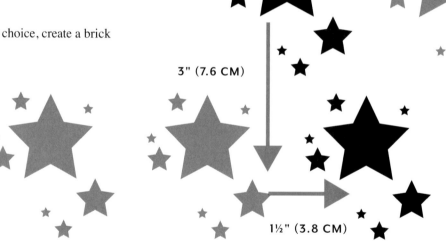

3" (7.6 CM)

1½" (3.8 CM)

The motifs in this all-over pattern are laid out in a brick repeat. Similar to a half-drop repeat, the motifs are repeated one full step vertically and one half step horizontally.

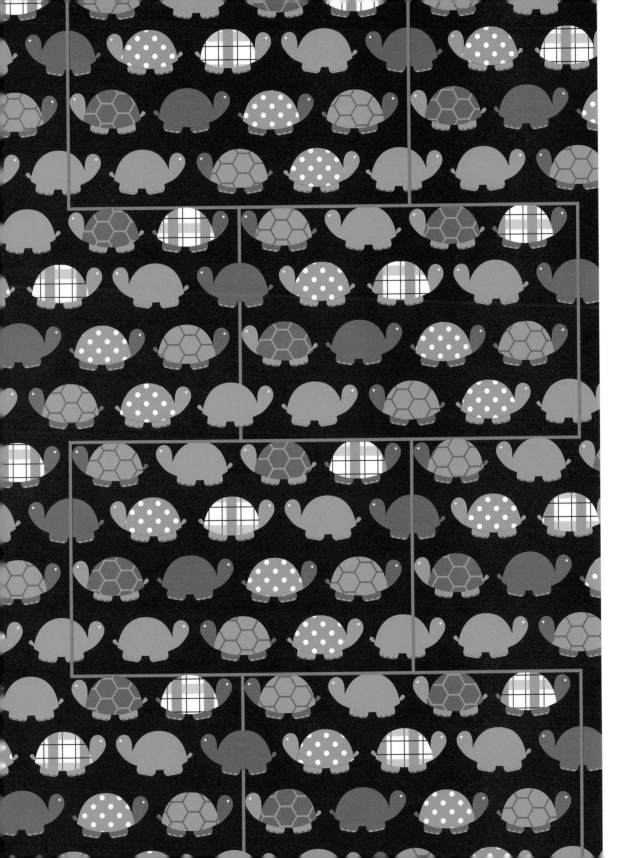

Examples of patterns using a brick repeat.

12" (30.5 CM) WIDE
X
8" (20.3 CM) HIGH

26

DESIGN A MIRRORED REPEAT

Mirrored repeats can create some fun and interesting visual effects. Some are even reminiscent of a kaleidoscope. Abstract artwork works very well with this kind of repeat, as it lends itself well to less rigid edges. This can make the pattern feel continuous without obvious breaks in the print. These repeats are great on fashion fabrics and other textiles. Mirrored prints also look great as placed prints (as opposed to all-over continuous patterns) in fashion and home décor.

● *YOUR MISSION*

Play with different motif types and create abstract prints. The beauty in these designs is in the experimentation, so flip horizontally and vertically and see what results you get.

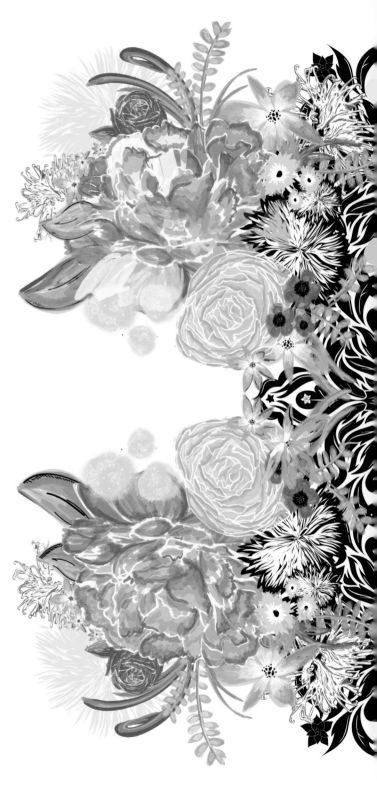

An all-over mirrored pattern

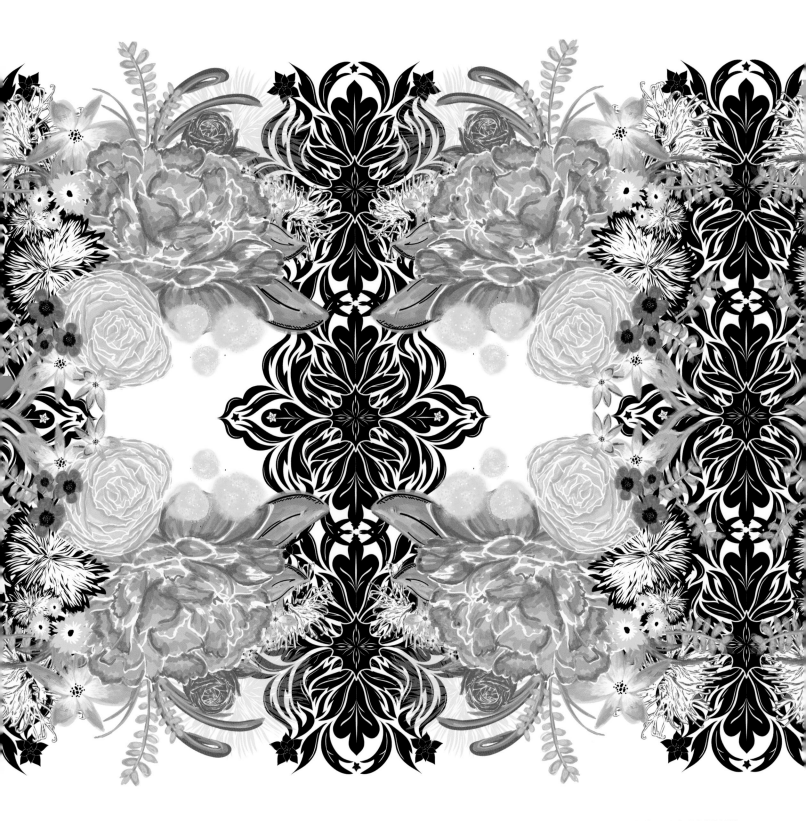

27

EXPERIMENT WITH DIRECTIONAL MOTIFS

TIP

Directional motifs are commonly found in paper products and home décor.

There are two types of directional prints: one-way prints and two-way prints. In both of these repeat styles, the motifs are arranged with the same orientation without rotation. Most often, we think of the motifs as right side up in this layout. For example, the butterflies will be straight up and down as opposed to rotated or turned.

One-way directional patterns feature all the motifs laid out in the same direction. This means there is only one "right side up" or one way of viewing these patterns.

Two-way directional patterns feature some of the motifs right-side up and some of the motifs rotated 180 degrees. Some of the motifs may be reflected vertically or horizontally as well.

Generally speaking (and depending on the looks of the motifs), directional patterns can look a bit more graphic due to their linear layouts.

So why is this distinction important? For some industries such as fashion fabrics, it's more cost-effective for a pattern to be a two-way directional print as opposed to a one-way print. This will allow for less waste during the cut-and-sew process. Of course, many garments out there use one-way directional patterned fabrics. This may result in a higher cost of goods and thus a higher retail price for garments of this nature. On the following pages we meet Rashida Coleman-Hale whose modern print style includes great directional patterns for sewing fabrics. Other industries, like wall coverings and gift wrap, for example, don't have the potential for this type of limitation.

● *YOUR MISSION*

- Find and collect five examples of directional repeats.

- Then using the method/medium of your choice, create a one-way directional pattern.

- Then create a two-way directional pattern.

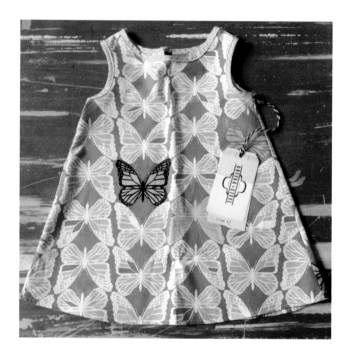

Rashida's directional butterfly print

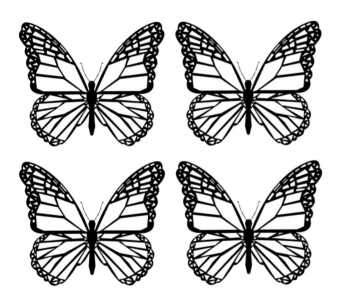

ONE-WAY DIRECTIONAL

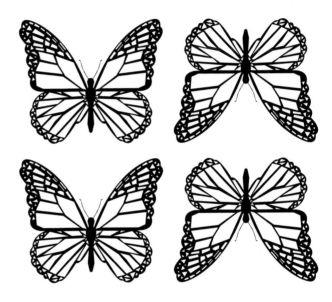

TWO-WAY DIRECTIONAL

Here, you can see the difference between a one-way direction pattern and a two-way directional pattern. With a one-way directional, all the motifs go the same way. Observe in the two-way directional pattern that two of the butterfly motifs are flipped in the opposite direction.

DESIGNING REPEATS

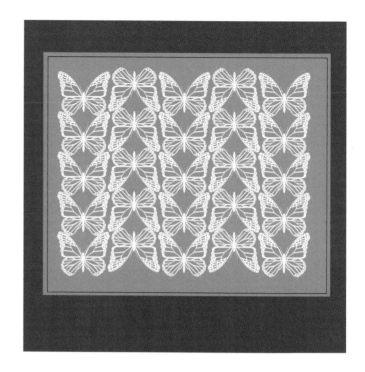

Rashida Coleman-Hale

Rashida Coleman-Hale is a pattern designer, fabric designer, author, and one of the founders of the breakout fabric company Cotton & Steel. Her work is often influenced by the whimsical look of Japanese design, and it's full of playfully graphic motifs and color stories. Rashida often uses directional prints in her work. She is brilliant at creating a sense of movement and intrigue with this simple layout style.

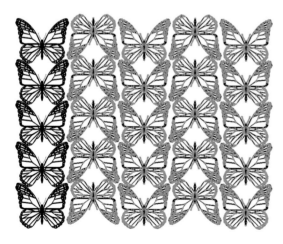

Rashida copies her original row of butterfly motifs and alternates flipping the entire row to build the two-way directional pattern.

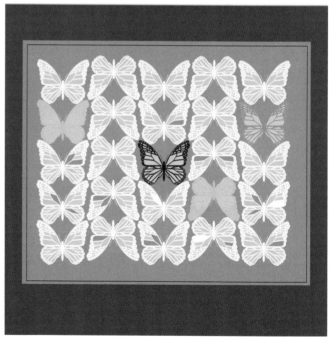

Next, she adds her desired ground color and motif color. Finally, she continues to add color to various parts of the motifs to create visual interest. Rashida's full pattern and an example of how it can be executed on the surface of a product are shown opposite.

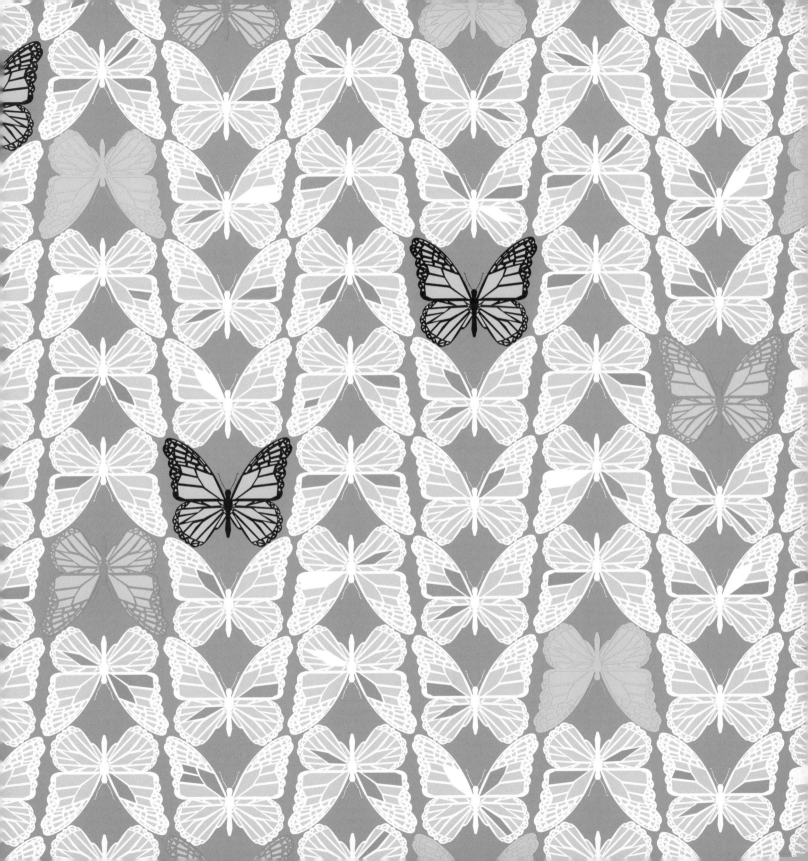

EXPERIMENT WITH TOSSED MOTIFS

A tossed pattern refers to the random direction of the motifs. The motifs are rotated, flipped, and reflected—or a combination of the three—to create a pattern without a discernible right side up. This pattern can be viewed from any direction and each will seem "right."

Important distinction: A tossed print can still have a direction. A one-way tossed print features motifs that have one way of viewing to be right side up. This means the motifs can be rotated any direction within the 90-degree and < 90-degree area. In other words none of the motifs are upside down.

A two-way tossed print has motifs that are rotated to varying degrees within the entire 360-degree plane. This allows the pattern to be viewed from any angle. This type of pattern is often preferred in fashion fabrics.

Speaking purely from an implementation perspective, tossed prints are the most versatile and user friendly of all the pattern layout types as they allow for less waste during any cut-and-sew processes. They are easiest to work with, as there is no wrong way when placing them onto products. This is especially true for two-way tossed prints.

● *YOUR MISSION*

• Find and collect five examples of tossed repeats.

• Then, using the method/medium of your choice, create a one-way tossed repeat with one motif.

• Using the method/medium of your choice, create a two-way tossed repeat with at least three motifs.

Tossed patterns arranged just as they sound—
the motifs are tossed about in a random manner.
They feel effortless, easy, and still balanced as
these examples by Jessica Swift (at left) and me.

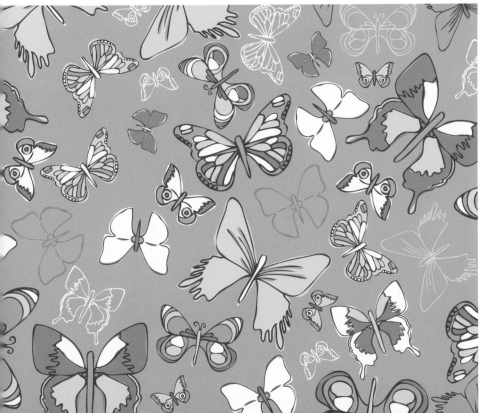

29

DESIGN A SMALL-SCALE PRINT

The scale of a print is determined by the size of the motifs. In this exercise, we're going to play with small-scale prints. Any kind of print can fall into the small-scale category, but some styles, such as ditsy prints and foulards, are traditionally executed with small-scale motifs. There is no hard rule concerning the size of a motif to create a small-scale print. It's more of a visual interpretation. Often, this may be relative to other prints in a collection. Small scale can mean different things for different product categories. For example, patterns for quilting fabric often use small-scale prints so when the fabric is cut into small pieces for sewing, the idea of the print is not lost. However, a product category like wall coverings may have a different standard for what constitutes a small-scale print. This is simply because the end use will be on a much larger surface.

You can find small-scale prints across all product categories, from textiles to stationery to flooring and more.

● *YOUR MISSION*

Create three small-scale prints using motifs that are no larger than 1 inch (2.5 cm). Vary the style of the prints you create (one floral, one geometric, etc.).

5" (12.7 CM) SQUARE TILE

Here you can see examples of small-scale prints with measurements for easy reference and a few examples of small-scale patterns.

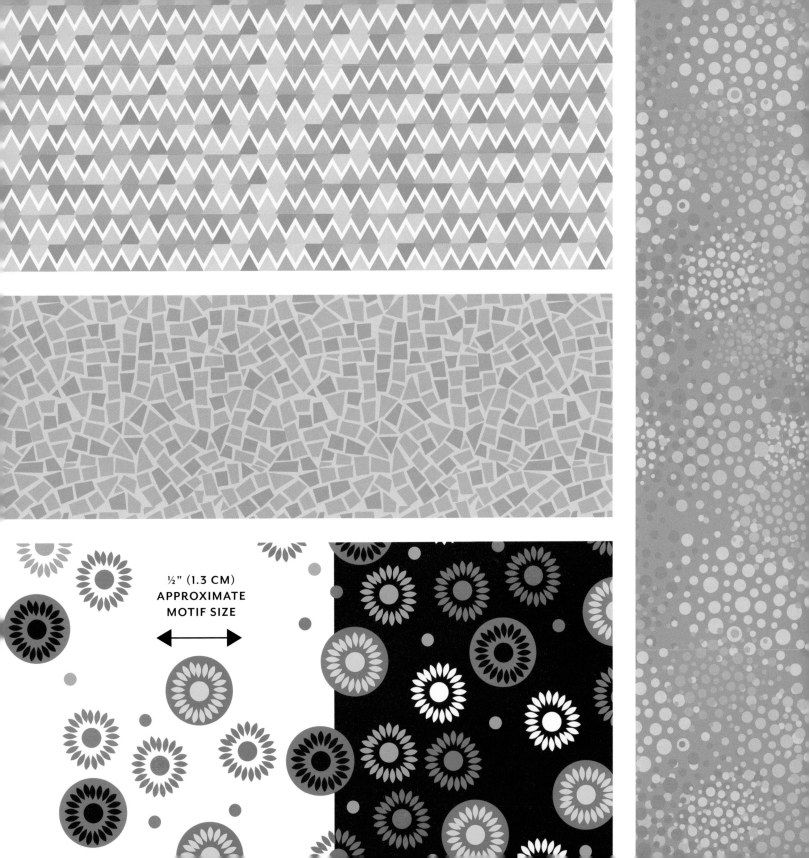

½" (1.3 CM)
APPROXIMATE
MOTIF SIZE

30

DESIGN A LARGE-SCALE PRINT

Large-scale prints use large motifs to create bold statements on the products and surfaces they adorn. Depending on the product category and repeat printing capabilities, motifs in large-scale prints can be quite large. Upholstery fabric, for example, may have a 25-inch (63.5 cm) repeat and, therefore, can carry quite large motifs. Wall-covering and contract textiles used in public spaces like hotels and universities may also use patterns with very large motifs. In these cases, large motifs are often necessary to suit the large spaces they will fill.

● *YOUR MISSION*

Create three large-scale patterns using one of the repeat sizes listed in the chart. Vary sizes of motifs, density, and style for each of the three patterns.

TIP

Standard rotary printing used on many textiles can accommodate up to a 25.25-inch (64 cm) width of repeat, while the length can be nearly any measurement. Use the opposite chart and consider it when creating your patterns and then collections. Remember that you have the opportunity to work pretty large if that suits your style. Be sure to think beyond the piece of paper in front of you. Always consider the vision for the application of the pattern, which in some cases will be quite large. Opposite is a chart of the repeat sizes available in rotary printing.

This print features a cluster of flowers nearly 8-inches (20 cm) wide as the focal point, making this a large-scale print. This large-scale pattern executed on fabric may be great for bedding or wall coverings or another typically large surface.

STANDARD SIZES FOR ROTARY PRINTING

This chart shows the standard sizes for rotary printing. This printing method is commonly used in printing textiles. The images are engraved on a cylindrical drum, the inks are applied to the drum, and the design is rolled out onto the fabric.

INCHES/CM

25.25 (64 CM)

12.62 (32 CM)

8.42 (21.4 CM)

6.31 (16 CM)

5.05 (12.8 CM)

4.21 (10.7 CM)

3.61 (9 CM)

3.15 (8 CM)

2.8 (7 CM)

2.52 (6.4 CM)

2.3 (5.8 CM)

2.1 (5.3 CM)

1.9 (4.8 CM)

1.8 (4.6 CM)

1.68 (4.3 CM)

1.58 (4 CM)

1.48 (3.8 CM)

1.4 (3.6 CM)

1.33 (3.4 CM)

1.26 (3.2 CM)

**6" (15.2 CM)
CLUSTER OF MOTIFS**

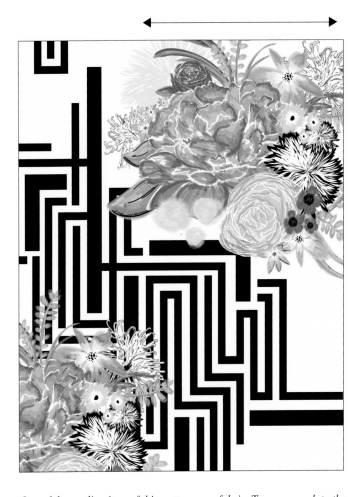

One of the applications of this pattern was fabric. To accommodate the large motifs and large clusters of motifs, the fabric was printed at a 25.25-inch (64 cm) tile size.

101

31

CREATE A DENSE PRINT

Like scale, the density of a pattern plays a big role in the look and feel of a print. The density of a pattern refers to the spatial relationship of the motifs to one another. A print that is dense is not going to have a lot of negative space. Another way to see it: In a dense print, you will see less of the ground color showing through.

The dense print has become a signature look of the work of Elizabeth Olwen. Along with her amazing color sense, Elizabeth's work uses sweet motifs arranged in a compact manner. This dense arrangement gives her work a wonderful sense of flow and movement. She shares her work and process on the next few pages.

● *YOUR MISSION*

• Create one large-scale dense print.

• Design one small-scale dense print.

You can get a fantastic peek into Elizabeth's starting process here. She begins with the individual motifs such as florals and mushrooms. She then arranges these motifs into a dense, repeat pattern.

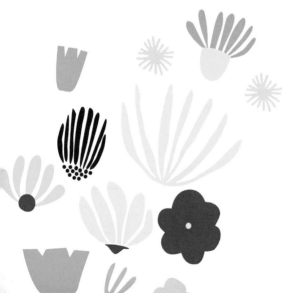

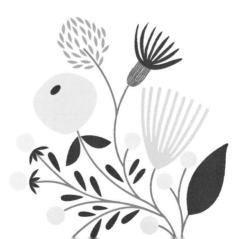

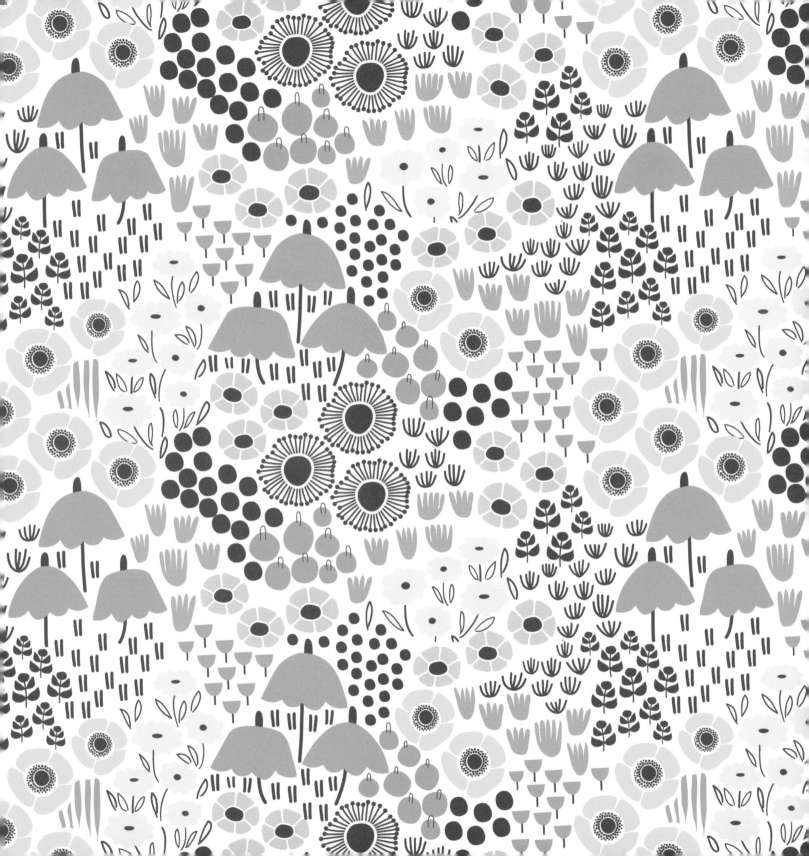

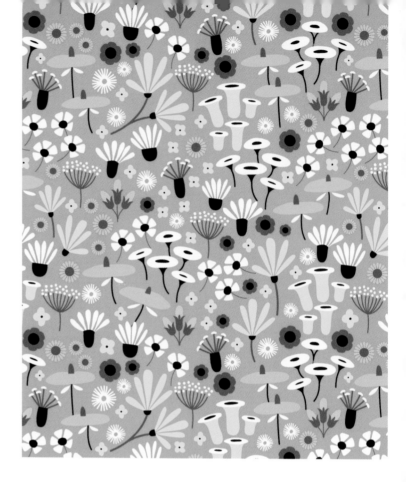

Elizabeth Olwen

Elizabeth Olwen is a Toronto-based surface designer. Inspired by pastoral beauty, nature in its most playful forms, folklore, and romance, Elizabeth's work is driven by the desire to leave something beautiful behind with every step she takes. Her obsession with patterns began when she was a child; she would become mesmerized by the orange floral drapes in her mother's kitchen. Surrounded by bold, unapologetic prints, she could lose herself in patterns: a window to faraway places. Through the years, the love of patterns remained and inspired her to start making her own. Elizabeth loves old wallpapers and vintage fabrics, cannot be forced to choose a favorite color, and is hopelessly devoted to travel. She has a growing collection of licensed products available in the market, with clients such as teNeues Publishing, Cloud9 Fabrics, The Land of Nod, Target, and Madison Park Greetings.

Through a designer's eyes:

Three words to describe Elizabeth's work: fresh, organic, modern-vintage.

If Elizabeth were a city: Berlin. It's got romantic European charm where all the details have been considered, but is also full of beautiful parks with flowers and trees. It's a city of visual adventure.

Color obsession: I'm loving Tomato!

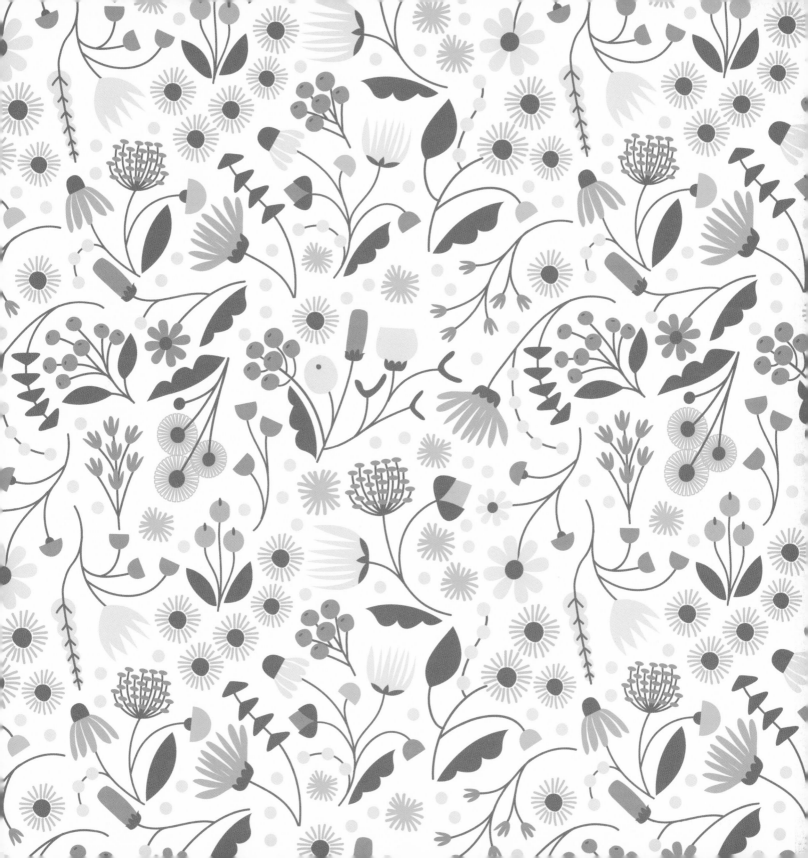

32

CREATE AN OPEN PRINT

Just the opposite of a dense print, an open print has lots of negative space around the motifs. This type of pattern will have lots of the ground color showing through, and the motifs will be farther apart from each other. Often open prints do not feel quite as active as dense prints and there's a feeling of lightness, as if the motifs have space to breathe.

● *YOUR MISSION*

• Create one large-scale open print.

• Create one small-scale open print.

In this image, it's easy to see the difference between a dense and an open print. The second image has more negative space, making it a nice complement to the first image in a collection.

33

ADD DEPTH AND LAYERS TO A PATTERN

TIP

There are many great resources for digital textures online. One of my favorites is Shutterstock.

So now you have all the basic building blocks of creating a pattern and even a pattern collection—whoo! As you start to play more with color, scale, and density, you will begin to explore by adding more depth to your work. This can help to provide more nuance to your patterns and more deeply develop your story.

So how to begin? When we first start making patterns, everyone usually starts with a solid ground color and arranges the motifs on one plane or layer. Now, I invite you to start thinking about adding more layers to your original motif concepts. Perhaps you use a pattern of silhouettes in the background or you draw some open line work on top of your motifs. Sometimes, I like to play with the opacity of motifs to overlay on top of my initial pattern. There are countless ways to do this. Here are some examples to get your mind working.

● *YOUR MISSION*

Part of the process of creating patterns and art in general is gaining the ability to edit your work. Look back through the patterns you have created. Is anything looking a bit flat now that you have this new perspective? If so, rework a few and review with fresh eyes. There's a fine balance here, as with all patterns. Creating depth is nice, but it's also important to know when to say when!

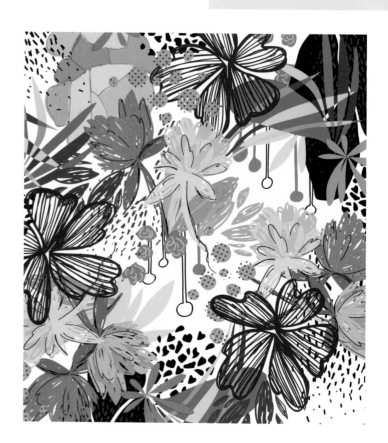

These patterns feature lots of layering of motifs, which gives them all a feeling of richness and depth. Consider your color choices when creating patterns with lots of layers. Using tonalities of colors can help with the illusion that motifs are pushing forward and popping off the page or receding further away.

34

ADD TEXTURE TO A PATTERN

Adding texture to your patterns is a great way to give them more life and a more organic feel. So many patterns are created digitally today, it's nice to still maintain that hand-drawn or hand-created effect. There are so many different ways to add texture to any design. You can create your own textures, which is really fun. You could then scan them and add them to your design digitally. Conversely, you can also find an endless number of digital textures online.

● *YOUR MISSION*

Adding texture to your patterns is a great way to give them more life and a more organic feel. So many patterns are created digitally today, it's nice to still maintain that hand-drawn or hand-created effect. There are so many different ways to add texture to any design. You can create your own textures, which is really fun. You could then scan them and add them to your design digitally. Conversely, you can also find an endless number of digital textures online.

This image illustrates the difference between the same pattern with and without texture.

35

CREATE A REPEAT BY HAND

Creating repeats by hand is a great way to get into the groove of pattern design and really digest the relationship of motifs and space in a more tangible way than working digitally. This may mean actually drawing the same motifs over and over. Or this can mean painting (or using a medium of your choice) a single repeat tile ready to repeat over again digitally. Or, such as in the case of Leah Duncan, it can mean repeating a pattern over and over via screen printing. By working this way, you can better get a sense of how a pattern will translate onto an actual product such as textiles or wall coverings, for example. You can better get a sense of how a pattern will translate onto an actual product like textiles or wall coverings, for example. Working by hand is also nice because you will undoubtedly have little imperfections or "happy accidents," as I like to call them. This only lends to giving your work a more organic feel, which is great.

Supertalented Leah is a master at creating her patterns using a screen-printing process. Working this way is key for Leah to create the organic feeling that is part of her signature style. Before Leah shares her screening process, let's explore creating your repeat by hand.

It's very simple to create a straight repeat with a single motif by hand.

- First, decide how far apart you would like the motifs to be spaced. Choose this measurement both vertically and horizontally. They don't need to be the same; however, for the sake of simplicity, it may be easier to start with a square repeat.

- Next, create a grid by drawing a faint line with a pencil and straightedge. For example, if you decided on a 3-inch (7.5 cm) repeat, then you will draw a vertical line every 3 inches (7.5 cm) and do the same horizontally.

- Next, you will place your first motif with the edge and bottom of the motif lined up with the horizontal and vertical grid lines.

- If you use a stamp of a motif, you can repeat using the grid as your guide for spacing.

- If you have drawn a motif, you can make copies of the motif and place according to the grid. Affix to the ground paper and copy so you're left with your pattern.

Once you get the feel of laying out your patterns by hand, experiment with some applications of these techniques, such as block printing and screen printing.

- ● *YOUR MISSION*

 Practice creating a few repeats by hand in the method of your choice. Have fun with it and try out a new technique like block printing or screen printing.

Leah's by-hand process of choice is screen printing. Here you can see a few of the tools she uses to screen print both fabric and prints. On the next page, we gain insight into her process in her own words.

111 DESIGNING REPEATS

Leah Duncan

Leah Duncan is an amazing artist who uses screen-printing techniques frequently in her work. Leah's brand started with a dream and an Etsy shop in 2008, which has quickly grown to include international retailers as well as collaborations with companies such as Schoolhouse Electric, Urban Outfitters, O'Neill, and The Land of Nod. She is a force you must know! Her line consists of locally sourced textiles, stationery, and home goods with many items produced by hand in her studio. Each piece in Leah's collection is hand drawn and reflects her unique sensibility and soft color palettes. Inspired by a love of nature, her east Austin neighborhood, and her Cherokee roots, she has established a recognizable voice that speaks simplicity and beauty with quirky and organic themes.

"All of my work is scanned in and then output to film separations. From there each color is burned to a screen. Most of the prints I print by hand are one color, but if I'm venturing into more colors, we print the lightest color first and then move into the darker colors using a rotary press. Once the fabric is printed, it is flashed under a heat lamp to dry the ink and put into a pile to await printing the next color. To print the next color we test to line it up with the first color using our registration marks and then repeat the printing process until all of the colors are printed," Leah says.

Through a designer's eyes:

Three words to describe Leah's work: organic, quirky, and soft.

If Leah were a city: Austin, Texas. It's my home and my work is a direct reflection of my surroundings, from the Texas landscape to the fauna and flora around the city.

Color obsession: pink and yellow currently and always.

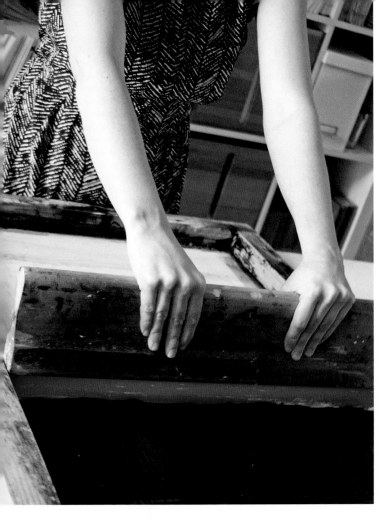
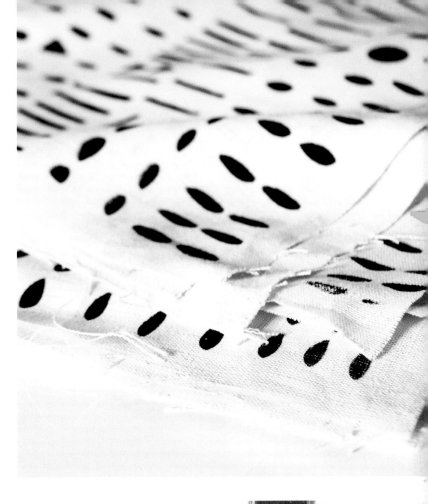
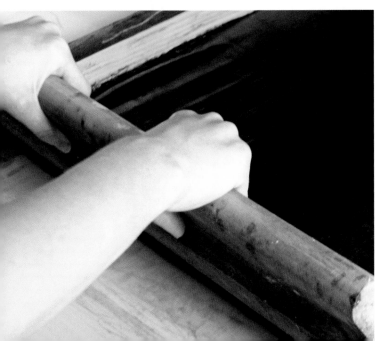
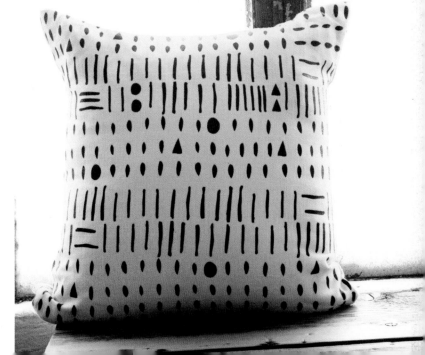

36

CREATE A REPEAT WITH
ADOBE ILLUSTRATOR

Michelle Fifis of Pattern Observer is here to share with
us the ins and outs of a magical (no, really) tool that
was added to Adobe Illustrator in one of the most recent
updates. The pattern tool! Yes, there is actually a tool that
will create patterns for you! Here's a look at how it works.

● *YOUR MISSION*

Practice creating both straight and half-drop repeats using the
pattern-making tool in Adobe Illustrator.

Step 1: Select all the objects that you wish to put into repeat.

Step 2: Click on Object > Pattern > Make. You will see a message reminding you that a new pattern has been added to the swatches palette. Click OK, which brings you into the pattern editing mode.

Step 3: You will now see your pattern tiled out on your art board. You can change the number of repeat tiles that you see, as well as the opacity of the copies, under the Copies preferences.

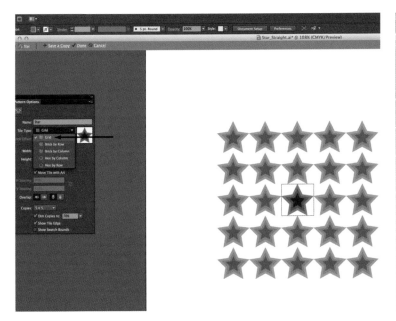

Step 4: After naming your print swatch, choose the type of repeat you wish to create. In this example, we're creating a straight repeat, which Illustrator refers to as Grid.

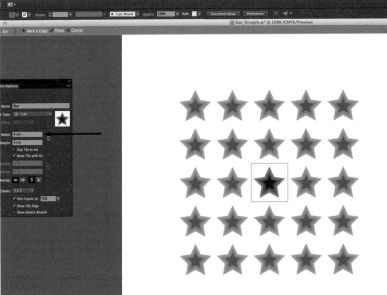

Step 5: The final step is to specify your repeat size, depending on the amount of space you would like between the motifs or the factory specifications. Once your repeat is complete, click <done> and Illustrator will save your pattern to your swatches palette.

DESIGNING REPEATS

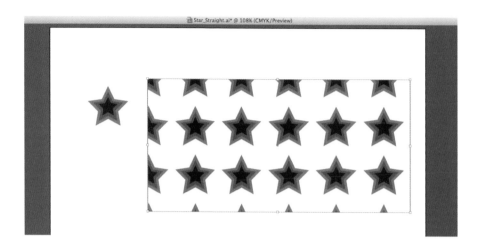

Step 6: You can then use this pattern to fill any objects you wish! If you would like to make any changes to the pattern, enable the pattern editing mode by double clicking on the pattern in your swatches palette.

Now let's use the same tool to create a half-drop repeat. Repeat Steps 1-3 (page 114–115), then continue as noted in the following images.

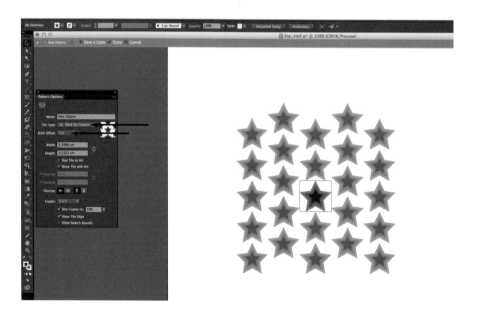

Step 7: After naming your print swatch, choose the type of repeat you wish to create. In this example, we're creating a half-drop repeat, which Illustrator refers to as Brick by Column, and set the offset to ½.

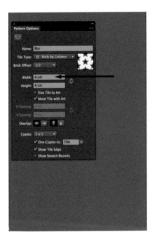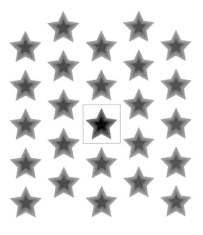

Step 8: *The final step is to specify your repeat size, depending on the amount of space you would like between the motifs or the factory specifications. Once your repeat is complete, click <done> and Illustrator will save your pattern to your swatches palette.*

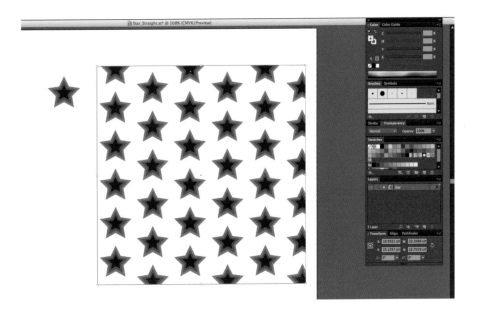

You can then use this pattern to fill any objects you wish! If you would like to make any changes to the pattern, enable the pattern editing mode by double clicking on the pattern in your swatches palette.

DESIGNING REPEATS

Michelle Fifis

Meet Michelle Fifis. Michelle is the founder and editor in chief of the popular textile-design professional development site, Pattern Observer. She founded Pattern Observer in 2010 after ten years in textile and surface design, both on the client side and as a freelancer. She lives and works in Portland, Oregon.

Michelle uses inspiration from many sources, including organic materials and found objects to create her fashion-forward patterns.

37

CREATE A REPEAT WITH
ADOBE PHOTOSHOP

Photoshop is a powerful tool that can be used for a wide variety of pattern-making needs. This is going to be your go-to program if you want to turn your hand-rendered creations, such as paintings, into repeat patterns. Stephanie Corfee gives us her insight on turning your paintings into repeat patterns.

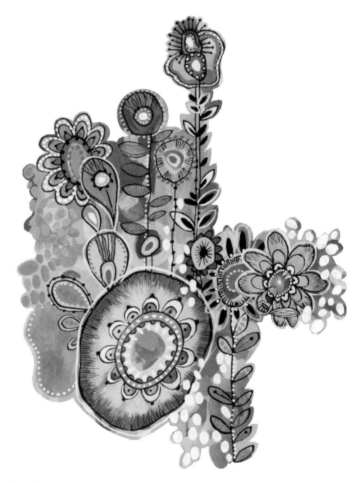

Use Photoshop to clip out various motifs from your painting and save each to its own layer.

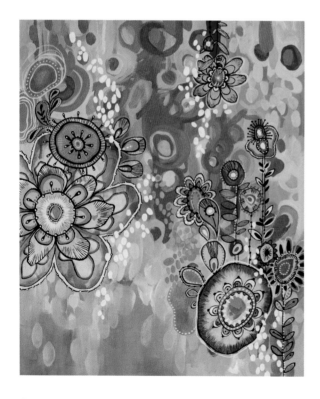

Start with a high-resolution scan of your original painting, like this painting titled Miss Ariel. Materials: acrylic on canvas

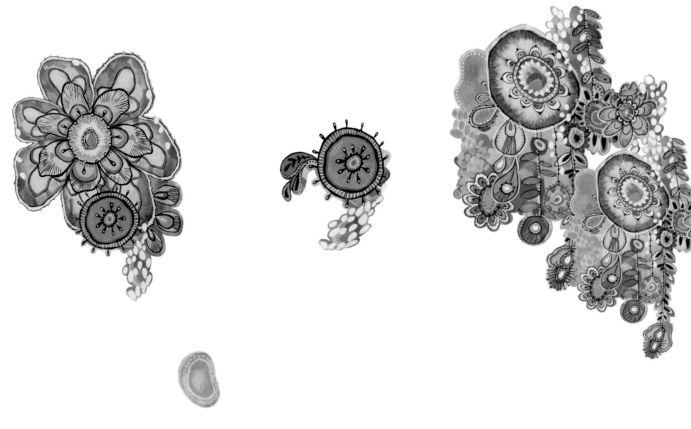

Use the lasso tool to grab sections you like. Copy each to a new layer and then clean up around the edges with a brush tool while zoomed in for precision. If your painting motifs have hard edges, use a hard brush. If softer edges are needed, use a soft brush for a smoother transition.

You might want to flip, scale, and recolor some of your clipped motifs to give you a better variety of elements.

DESIGNING REPEATS

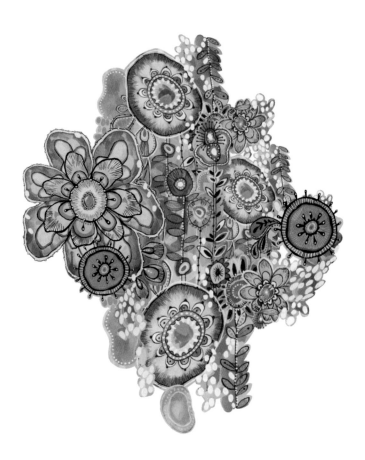

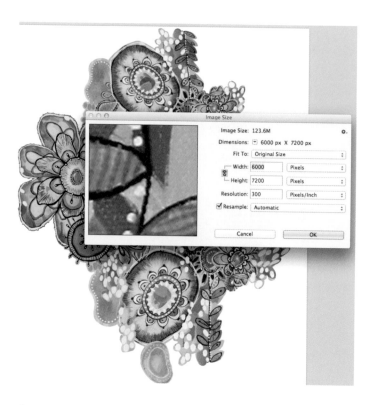

Assemble your clipped motifs in a loose oval or diamond cluster, making sure that none of the motifs touch the edge of your art board. Make copies of all motif layers so you retain the individual elements. Then, merge one set of all the motifs in your cluster to create a single layer with your oval or diamond shape.

In your menu toolbar, select Image > Image Size and then choose the pixels increment in the drop-down menus within the dialog box. Write down your image's width and height. Here, the width is 6000 px and the height is 7200 px.

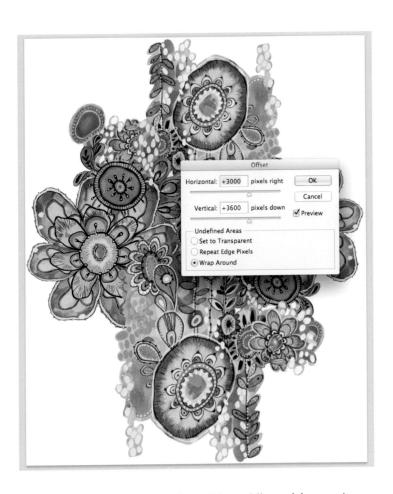

In your menu toolbar, select Filter > Other > Offset and then type in exactly half the measurements you recorded for width and height in the previous step. Here, the width will be 3000 px and the height will be 3600 px. Be sure Wrap Around is selected.

The resulting image shows your cluster divided perfectly into quadrants and shuffled to opposing corners, so that your repeat will match up precisely when tiled. It is essentially the frame of your pattern repeat.

DESIGNING REPEATS

Add a solid background color layer that coordinates with your art.

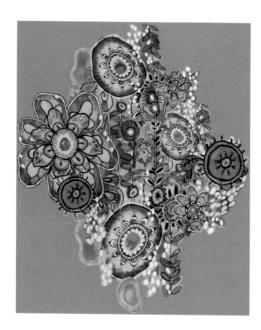

Turn off the frame layer to double check that your motifs do not touch or overlap the edges of the art board.

Now go back and use all those individual motif layers to fill the center space, making sure not to let any motif touch the edges of the art board. You could also just duplicate the offset layer and offset it again to get back a second copy of your original oval/diamond shape. That can be pasted in front of or behind the frame, but I like to add variety to the repeat by filling the center space with a fresh composition of the motifs. Save your layered PSD file. Then, flatten your file, select All, and select Edit > Define Pattern. Name your pattern and click OK. Check your work by adding a new layer to your file, a pattern fill layer from the layers palette.

Use the scale slider to watch your brand new pattern fill the space seamlessly!

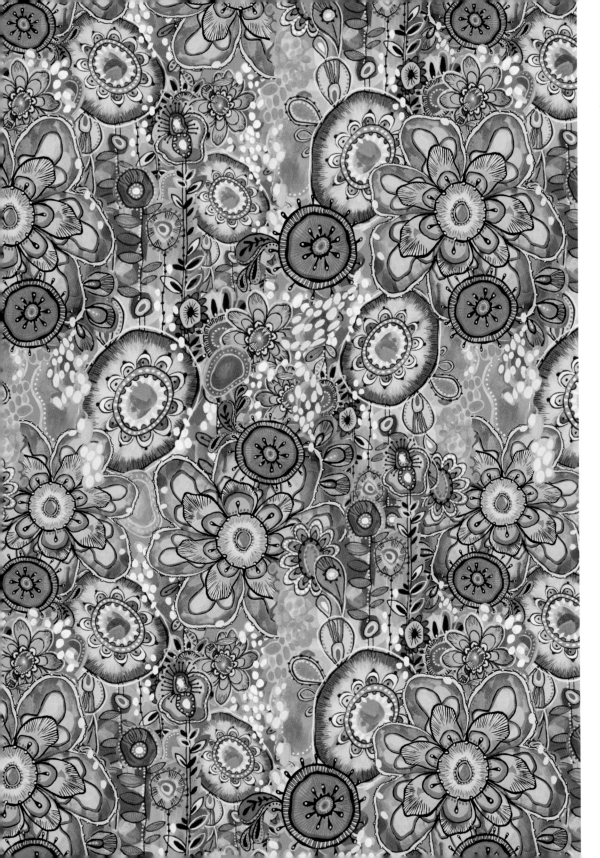

*The end result:
the Ariel pattern in
perfect repeat*

Stephanie Corfee

Stephanie Corfee is a beautiful, blonde ball of energy. She is supertalented, and her happy, colorful work adorns an array of products from home accessories to wall art to tech cases and more. You can find her merrily creating her vibrant creations from her new light-filled studio in Pennsylvania.

Through a designer's eyes:

Three words to describe Stephanie's work: vivid, whimsical, and spontaneous.

If Stephanie were a city: Oh my gosh....I haven't traveled enough to truly know. But in my mind, I'd imagine some sunny California surf town.... maybe Santa Cruz or Capitola?

Color obsession: I am really loving indigo and all of it's derivations. Grayed out indigo is beautiful, inky, dark indigo, pale tints you get when mixing with white. It feels very mature to balance out all of the crazy, wild brights and neons I love so well.

Stephanie's original Pixie painting, above, and developed into a repeat to the right

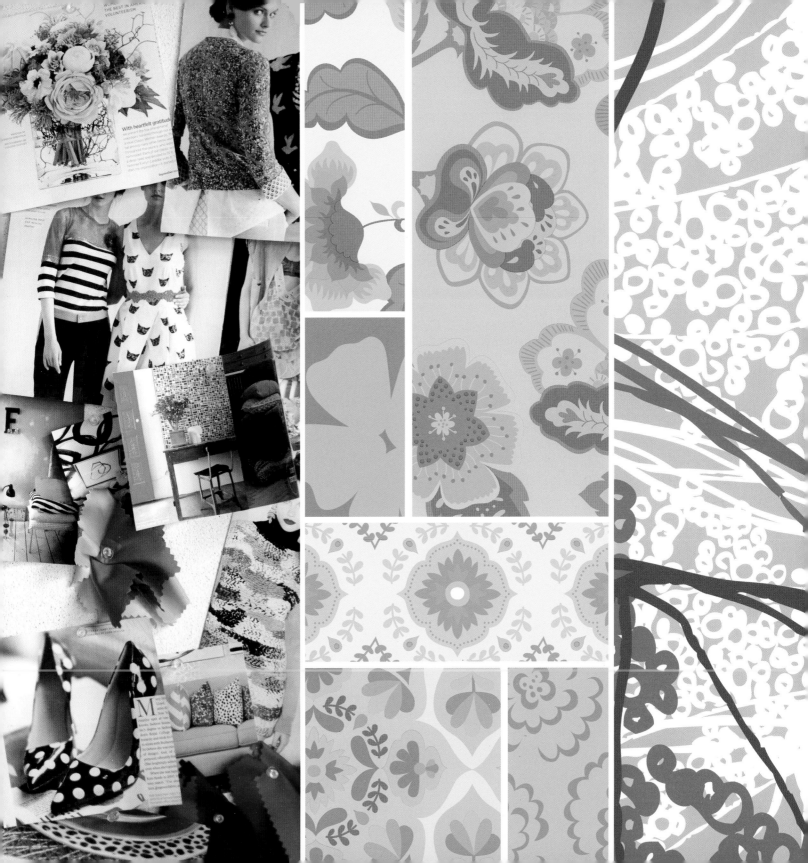

38 STUDY SUCCESSFUL COLLECTIONS

Now that you have some building blocks, you're ready to start thinking about building a pattern collection. First, it's helpful to start exploring what the word *collection* means to you. Many things can tie elements together to create any sort of collection. Color, shape, theme, place, size, and so on—these can all give a collection a strong, cohesive look. A collection doesn't have to feel perfectly matched. It can, and that's not a problem, but it's not required.

The Sisters Gulassa create pure magic with their eclectic collections. They have a wonderful gift for threading patterns together with a common theme, color story, or style that is always dynamic and intriguing. This is what makes their work so appealing to major brands worldwide. They have generously shared some of their collections with us on the next few pages from concept to finish.

● *YOUR MISSION*

- Observe the world in the context of building collections. Pull magazine tears, collect images online (Instagram and Pinterest are endless rabbit holes of inspiration), and snap quick images with your phone of things and color stories that are related to one another.

- Next, collect these images in one place so you can view them in direct visual relation to each other. Perhaps color is a strong element for you and your images naturally build a color story together. If not, this is not a problem; you can work on the color story later. Perhaps you simply have a collection of images that is tied together in a way that is clear to you. Maybe, for you, this link is shape, subject, or style. This exercise is for you to begin seeing images in relation to each other, so play, play, play.

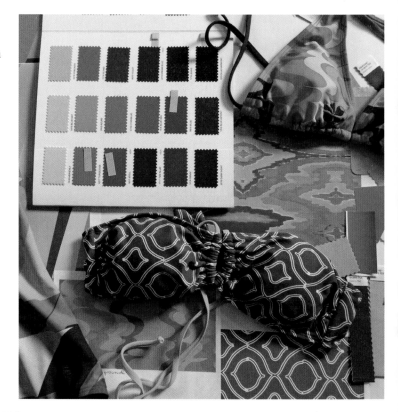

The Sisters Gulassa are masters at blending both organic and graphic shapes and using vivid color palettes to create vibrant intriguing pattern collections.

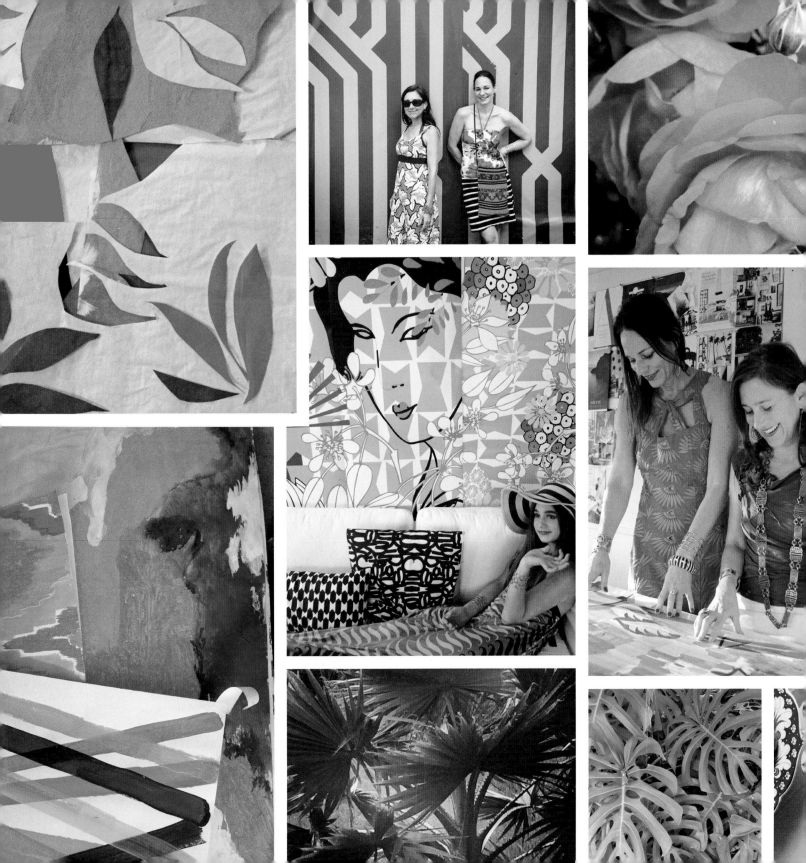

Sisters Gulassa

Meet sisters Cyrille and Lise. Together, they make up the color-loving global duo of Sisters Gulassa. They are crazy about color, pattern mixing, and the bright, bold "wow je ne sais quoi" that they call Vivid Living. They are a creative force by nature, but couple this with Lise's inspiration from her sunny California studio and Cyrille's from her studio in Vienna, and the creative collision is amazing to view.

Through a designer's eyes:

Three words to describe the Sisters Gulassas' work: vivacious, color soaked, and exuberant.

If the sisters were a city: A tropical island—the choice is yours. Because our designs are vibrant, vivid, lush, color saturated, abundant, blossoming in large scale, full of life, a testament to the beauty and abundance of nature herself.

Color obsession: pink. We both have had a continuing affair with all hues of the pink spectrum, from pale to neon. Pink, we love thee!

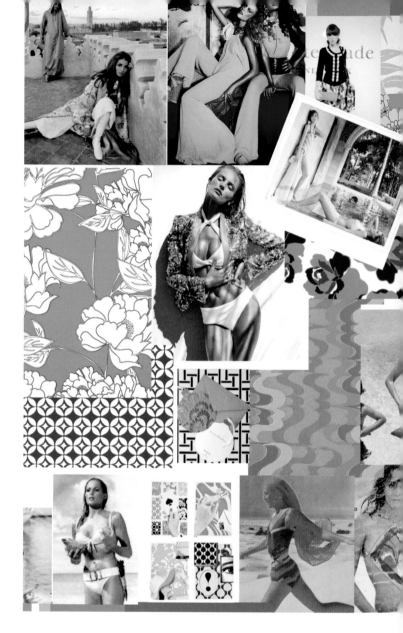

Inspiration boards are a great tool to see how your story is coming together with color, shape, and theme.

These prints are the result of collected inspiration and images pulled together on the inspiration boards.

39

CRAFT A STORY FOR YOUR COLLECTION

This is always a fun part of the process for me. In this exercise, you get to dedicate some time to developing the story for your collection. I believe that compelling collections have a story running through them. This story has the power to create a connection between the creator and the viewer of the collection. If this collection adorns product, the connection is built between the product and the consumer. This connection helps to create an emotional tie to the work for the viewer.

● *YOUR MISSION*

Create a narrative for your collection. Draft a few sentences that capture the feeling and story you want to convey with your collection. Don't stress! This doesn't have to be set in stone and never really needs to see the light of day. It's just an activity to help you get your creative flow going. Use descriptive language. Think with all your senses. Often, this exercise will even spark ideas for new motifs. Explore and jot it all down. Don't edit yourself and allow yourself creative freedom.

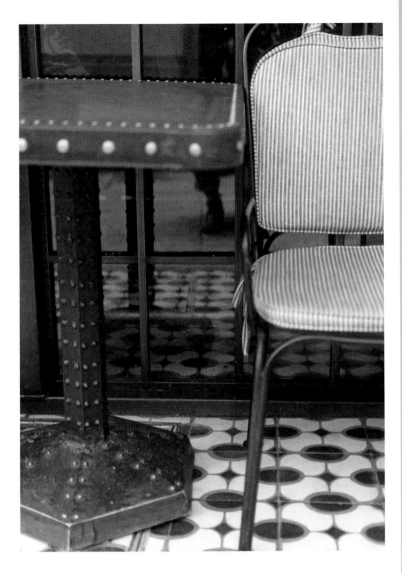

Shown here are some photos from my travels in Paris—evocative and visually rich images: bright yellow chairs against a graphic black-and-white wall in the Metro, (opposite, top); beautiful architectural details and ornamentation (opposite, bottom); classic furniture and tile in a café (above).

I look back through my travel photos again and again for inspiration, and I always find a story to tell. Part of why travel is so important to me is that it creates a built-in narrative. The essence of the place has the potential to come through in the designs. It's relatable to the viewer who's shared the experience of the place and a bit of fantasy for those who haven't yet traveled there.

USE IMAGES TO TELL THE STORY

Now that you've developed the story, it's time to collect imagery to support the story and continue the development process.

● *YOUR MISSION*

Pull images from all resources you like—magazines, online, photos, sketches—around a central story you would like to tell in your collection. If you're not working on the story you developed in the previous exercise, this inspiration can come from anywhere! Perhaps a trip you took or a book you read or even a visit with your grandmother may spark an idea and story for a collection for you.

Note: This is how I work. It may or may not work for you. Sometimes, the story that develops out of the previous exercise is so strong, you're ready to begin sketching straightaway. If this happens, run with it! Just be sure to get those images in your head onto paper as quickly as possible! These sketches may become your inspiration board for the collection.

41

CHOOSE MULTIPLE PALETTES

This is one of my favorite parts of my process. Playing with color! It's so easy for us to get stuck in a color rut. For a while there, I thought maybe I would actually start to bleed turquoise! In order to keep my collections feeling fresh and exciting, I am always forcing myself out of my color comfort zone. The best way for me to do this is to explore color and color palettes from all my favorite resources—fashion, travel, and nature. I love spending a full day ripping through fashion and travel magazines on the hunt for unique color combos.

You can certainly take baby steps to help you become more adventurous with your color palettes. Start with a color that's very comfortable for you to work with. Then begin to build your palette with colors you would not normally pair with this color. If it's a big ole mess at first, don't worry! This will simply help open your mind to different combos and help you to see new palette possibilities.

If trend is a strong factor in your work, it's important to develop sources and methods to help you understand what's coming around the corner with color. Remember, the work you design now will often find a home and hit market many months down the road.

TIP

Research resources to help you stay current and ahead of market color trends. Sites like WGSN.com and Stylesight.com will help you get started. Interested in pattern design for interiors? Investigate interiors trade shows like ICFF and Maison & Objet. Attending these shows will help to keep you on the forefront of what's next in both color and design.

● *YOUR MISSION*

• Spend the day pulling color inspiration from some of your favorite sources. This can be anything that resonates with you—magazines, photos from your travels, photos from that gorgeous wedding you just attended, a trip to the flower market, or something else. Then, pull this inspiration on a physical inspiration board or use a digital resource like Pinterest. You may even choose to bring these digital images directly into the design program of your choice for easy reference.

• Create three different color palettes using your new color inspiration.

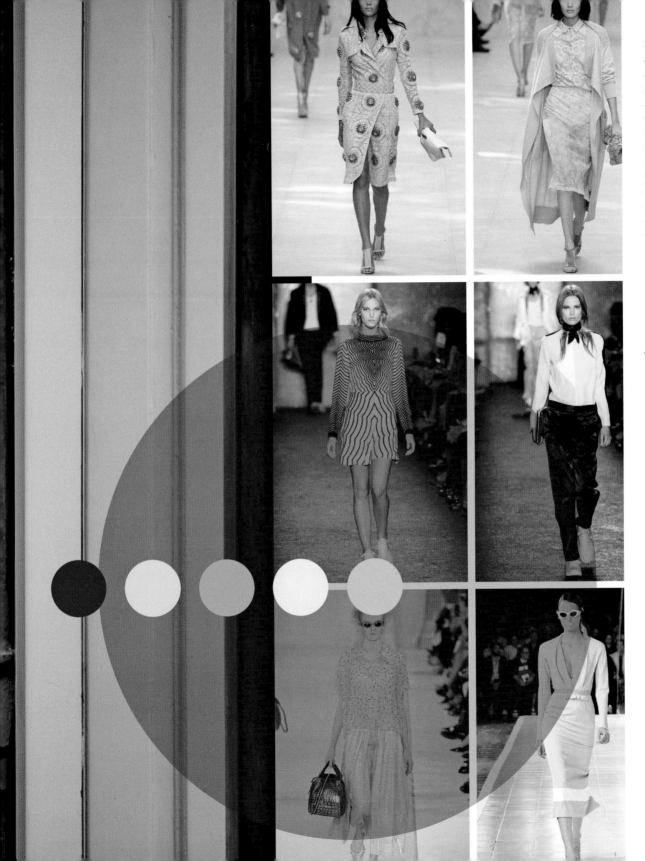

Travel and fashion are two of my biggest sources of inspiration. When I see an obvious common thread in color across many designers' work in a fashion season, and then see it reflected on the street as well, I know something big is happening.

(Opposite) These are examples of how objects and displays in the marketplace can spark inspiration for color palettes.

42 DEVELOP THE COLLECTION

You've worked on all the pieces of the puzzle, and now it's time to pull it all together. At this point, you should have a palette, an idea of a theme or look, and perhaps even a few sketches to get you started. Right now, you're likely overflowing with ideas. Don't worry; although you have all these elements that are great starting points, some tweaks, changes, and happy accidents are likely to happen along the way. This is the beauty of the creative process.

From here, there are many different ways to proceed. There is no right answer. Do what feels right to you. I will share with you how I go about things purely as an illustration of one of the possibilities.

For me, color drives my whole world. The color story is often what tells the story for me and sets the mood. It's only then that the theme and motifs begin to reveal themselves. So naturally for me, a color palette is the first order of business. I work with color from the beginning to the end, often tweaking along the way, but this thread continues to pull the story together.

Next, I develop what's often called the main print of the collection. This is the hero print that is usually immediately associated with the collection. I create this print fully in color with any and all the layers, textures, and depth I see it needs.

Next I create what I call "friends" of this hero print. These pieces make good coordinates to the main print. I am always thinking of potential end uses in this process. So perhaps I see the main print as bedding and then the friends could be throw pillows or upholstery for a chair.

I often think in terms of spaces and interiors when I create (again, just a personal method, and there is no right or wrong method here).

I continue to create friends of the friends until I have a nice little family that can work together in a variety of scales on a variety of products. I like to make sure the friends are strong enough that they can stand on their own as beautiful prints independent of the collection as well.

By contrast, I have a good friend in the industry who works in the completely opposite manner. She creates all of her patterns in black and white, either by hand or digitally. Then, color is the last bit of the story for her. So, you see, as you continue to play with pattern more and more, you will develop your own way of creating collections.

● *YOUR MISSION*

Develop a collection of at least six patterns that work together to create a feeling or tell a story. Remember, a collection doesn't have to be perfectly matched. Disparate pieces can go together if they are tied together by color, style, theme, or feeling.

I often start off with ideas about motifs and textures.
Arranging them into a pattern comes later in the process.

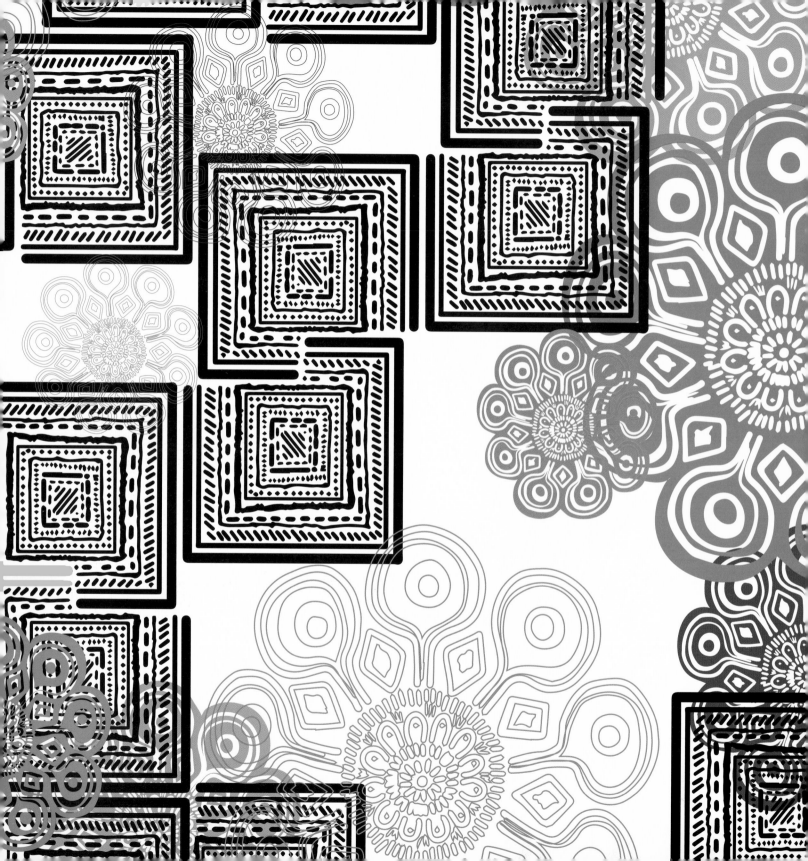

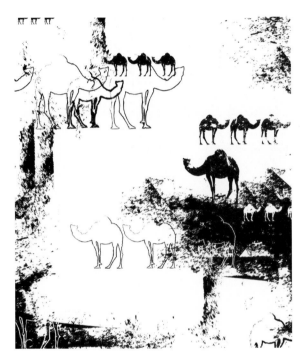

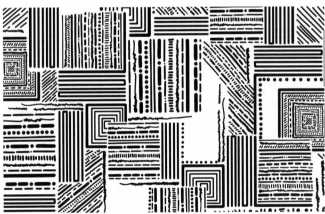

Development of friends to the hero print. Notice each print is not just a derivative of the hero print. Instead, they work to support the look, feel, and theme of the overall collection, and they all are strong enough to stand on their own.

DEVELOPING A COLLECTION

43

EXPLORE A MULTICOLOR PALETTE

TIP

Perhaps your first colorways used warm colors. Try creating a cool-colored version of the collection.

Soapbox alert! Color is so very important. It's often the first thing we experience when viewing artwork or products in the marketplace. The same artwork or product in a different colorway will completely change the viewers' experience. Whew—I didn't go overboard with that one!

So, you have just played hard to develop your color inspiration and the story of your collection, which is great fun. However, it's important to be able to see your work in different color palettes, as well. Of course, a different palette has the power to tell the same story in a different way or totally transform the story. That's the beauty and power of color.

Multicolor palettes are just as they sound. They are made up of many different colors. The use of more colors in your patterns affords you the opportunity to have more depth in your motifs and, in some cases, create a very dynamic print. Of course, the possibilities are endless, and these feelings can also be created with the other kinds of palettes.

On the following pages, check out how color can completely change the look and feel of a pattern.

● *YOUR MISSION*

Using the collection you just created, recolor the patterns with a new color palette. Try not to repeat any of the colors used initially so you are challenged to create something entirely new.

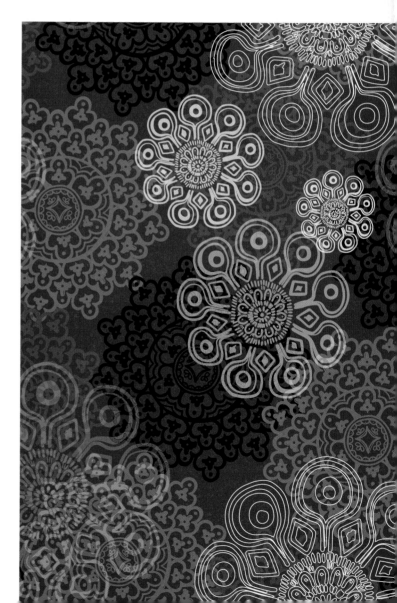

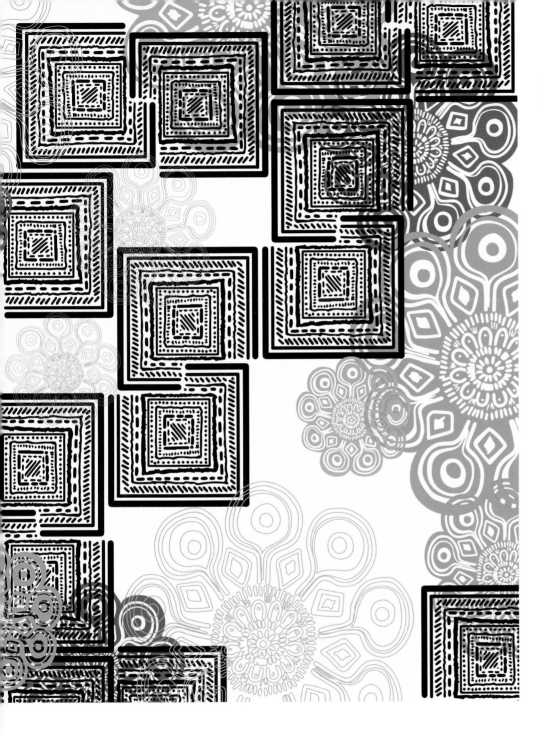

Prints from the Rooted collection (see pages 140, 141) recolored in a cool multicolor palette.

TIP

If the first collection used only two or three colors, experiment with a more multicolored palette this time. In this case, you will not be able to change the colors in a one-to-one relationship. You will need to adjust some of the color placements in your motifs to accommodate a larger palette.

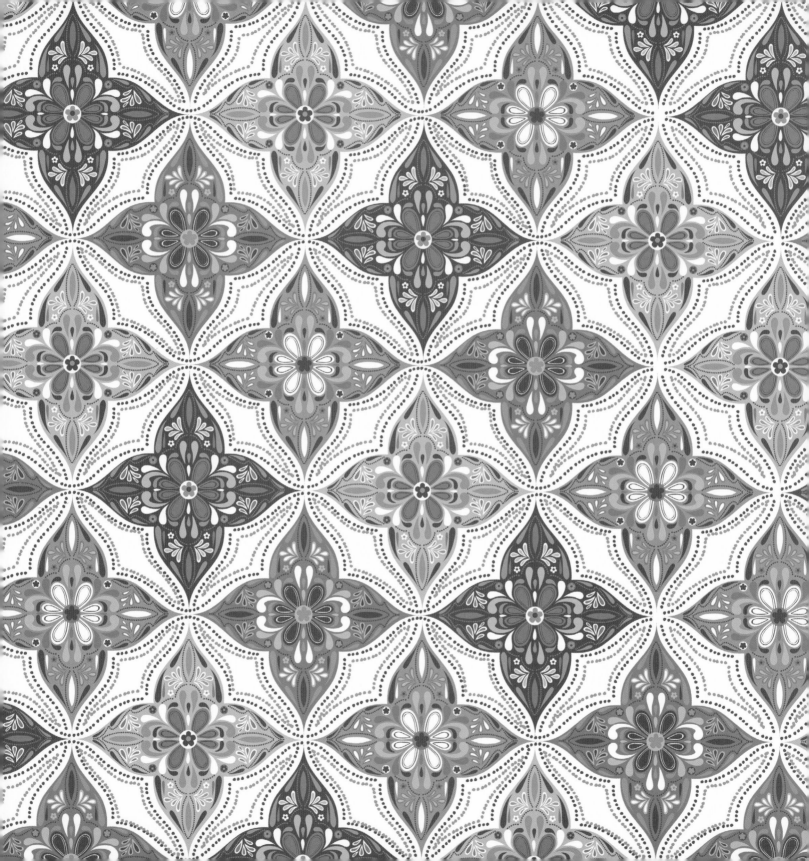

Notice how the same pattern feels very different in varying color palettes. The green colorway feels light and fresh while the purples feel moody and romantic. Also see how the use of tonal colors in this multicolor palette allows for greater depth in the design.

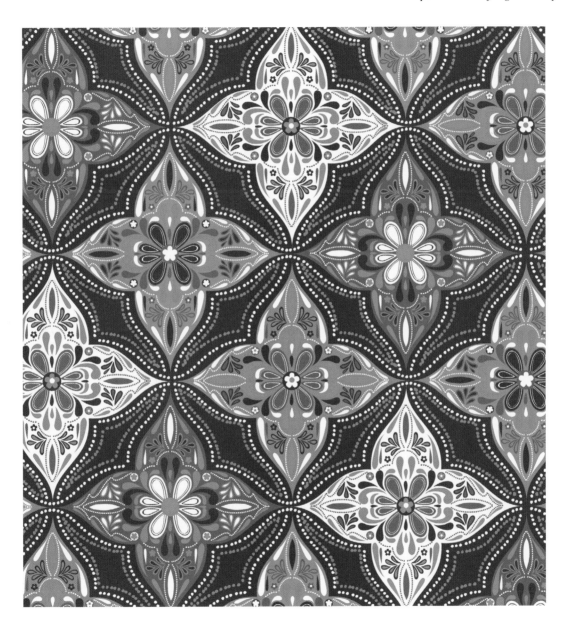

DEVELOPING A COLLECTION

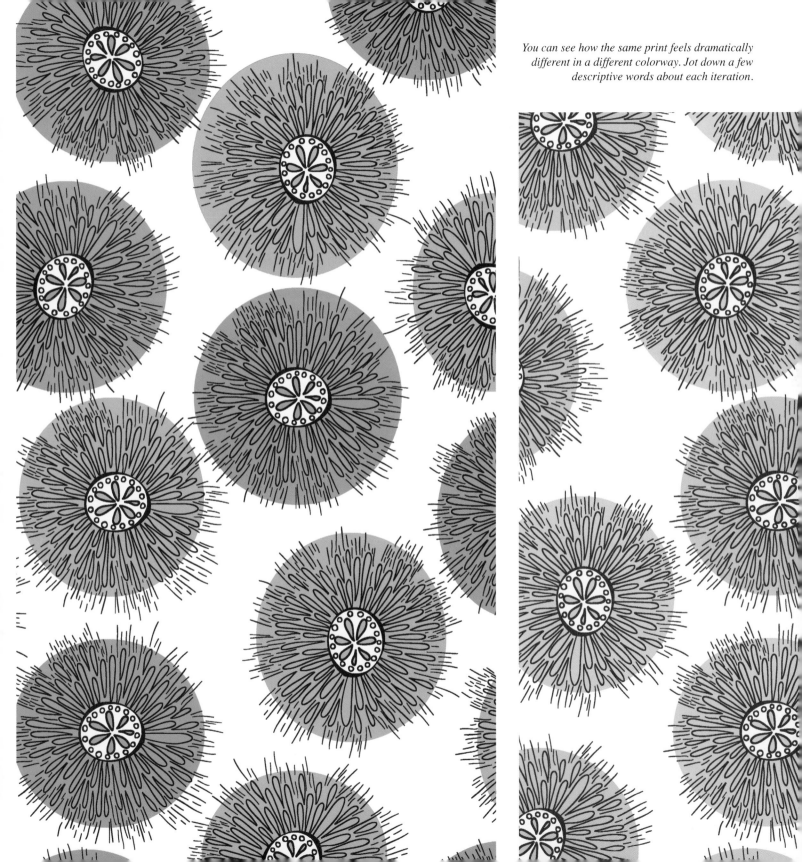

You can see how the same print feels dramatically different in a different colorway. Jot down a few descriptive words about each iteration.

Same leaf design—totally different expression. One feels light and airy while the other feels deep and sophisticated.

DEVELOPING A COLLECTION

44 EXPLORE A SIMPLE PALETTE

Let's continue to play with color. This time, let's explore simple palettes. A simple palette is composed of a handful of colors, likely no more than three or four. Simple palettes are great because they can very quickly relay a clear, strong feeling to the viewer. For example, when used with black or white, a simple palette can feel graphic in nature. Red, white, and blue can feel patriotic or nautical. Using beige, cream, and light blue can instantly convey the feeling of the beach. Red, green, and pink can immediately feel holiday. Of course, these are just examples that aren't set in stone, but you can see the possibilities.

● *YOUR MISSION*

Continue to work with the same collection, but recolor the patterns using a simple palette of no more than three or four colors. You can see from the examples shown that your collection can immediately take on a whole new feel. This could come in handy by turning an everyday damask pattern into a holiday pattern, for example. Play with different simple palettes and notice how the collection takes on an entirely new look.

A simple three-color palette, (top) and a simple two-color palette, (bottom).

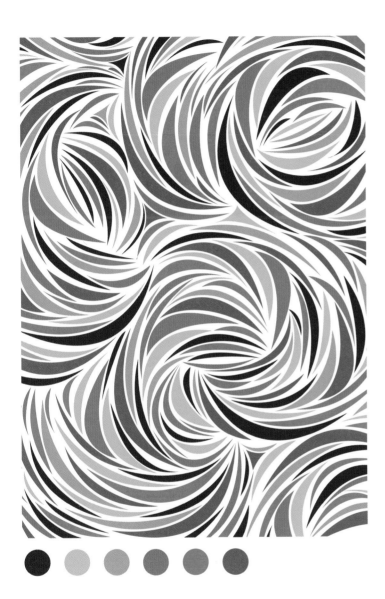

A color palette that conveys a holiday feeling.

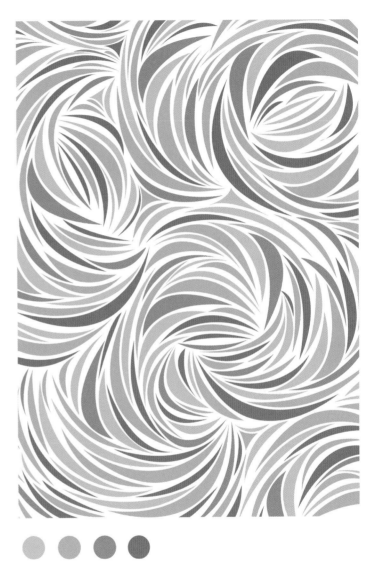

The same print in a varied color palette gives an entirely different feeling.

151

45

EXPLORE A TONAL PALETTE

Tonal palettes are created using a range of tints and shades of a color. The colors in the palette don't need to all be exact tints and shades of the starting color to work. In fact, a little variation is often more interesting. For example, a palette of greens, turquoise, and lime tones could still be considered a tonal palette.

Patterns colored with a tonal palette can often feel very sophisticated and work well in a variety of product categories from wall coverings to stationery to flooring and textiles.

● *YOUR MISSION*

Recolor the patterns in your new collection using a tonal color palette.

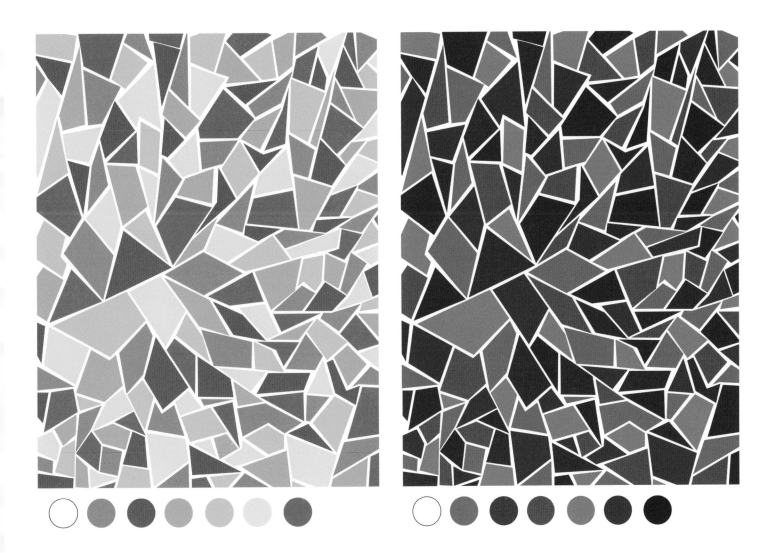

Exact tonal palette: The colors in this palette are exact tints and shades of the vibrant red.

The colors in this palette work together to create a tonal feel for the pattern; however, they are not exact tints and shades of one color.

153

46

EXPLORE A HIGH-CONTRAST PALETTE

High-contrast palettes use colors that are complementary
to each other on the color wheel. They often create very
intense, dynamic effects in patterns. Examples of high-
contrast palettes are orange and blue or black and white.
This, of course, is a very basic way to create a high-contrast
palette. These palettes do not have to be only two colors.
A simple palette of black, white, and pink can also create
a very high-contrast effect.

● *YOUR MISSION*

Using your collection of patterns, recolor the prints with
a high-contrast palette.

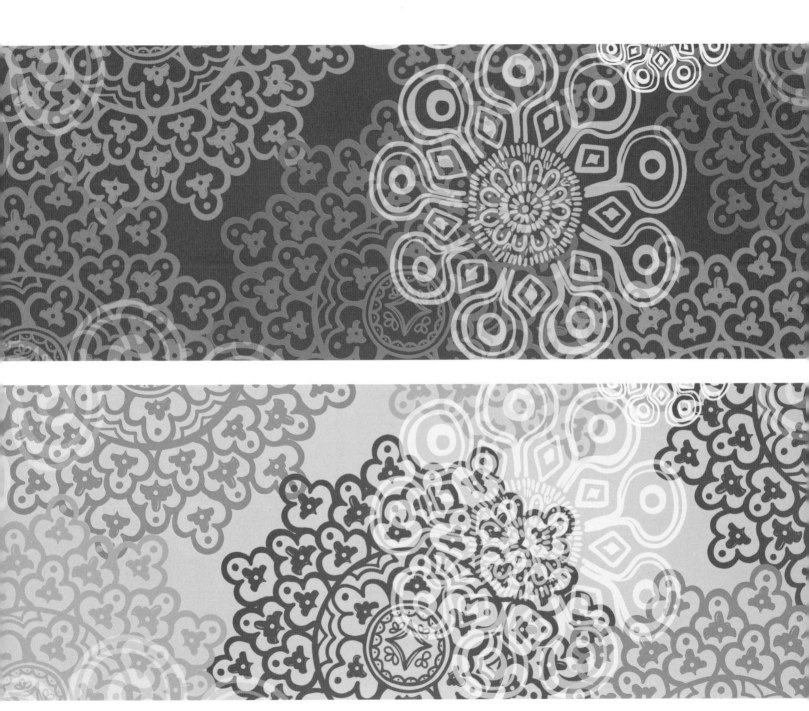

Examples of the same print recolored with complementary colors

DEVELOPING A COLLECTION

47 CREATE BALANCE WITH SCALE AND DENSITY

Now let's make all these components work together in a collection. Scale and density are two of the key components in creating a compelling pattern collection. These elements work together to create movement, depth, and balance.

● *YOUR MISSION*

• Go back to the collection you created in an earlier exercise. Examine the patterns that make up your collection. Do they have a variety of large- and small-scale prints as well as dense and open prints? These are the things that will make your collection feel visually balanced.

Did you answer, "No"?

• If you answered no when you reviewed your collection, don't worry! Learning to edit your patterns with this kind of critical eye is all a part of the process. If you noticed that the patterns in your collection are all the same or of similar scale and, perhaps, density as well, work on editing the patterns you feel could change to make the collection more dynamic.

Did you answer, "Yes"?

• Well, good for you! Maybe you have just a few minor updates you would like to make in light of reviewing the collection through this filter. If not, time to create a new collection, keeping these elements in mind. Go to work creating another collection of six or more patterns while considering scale and density.

TIP

I like to put all my patterns up on a wall when I am working on a collection and step back from them to better assess how they're working together. This way, you can really see how they relate to each other, and the needed tweaks may become more obvious to you.

In this collection of patterns, you see the variation of both repeat sizes and sizes of motifs.

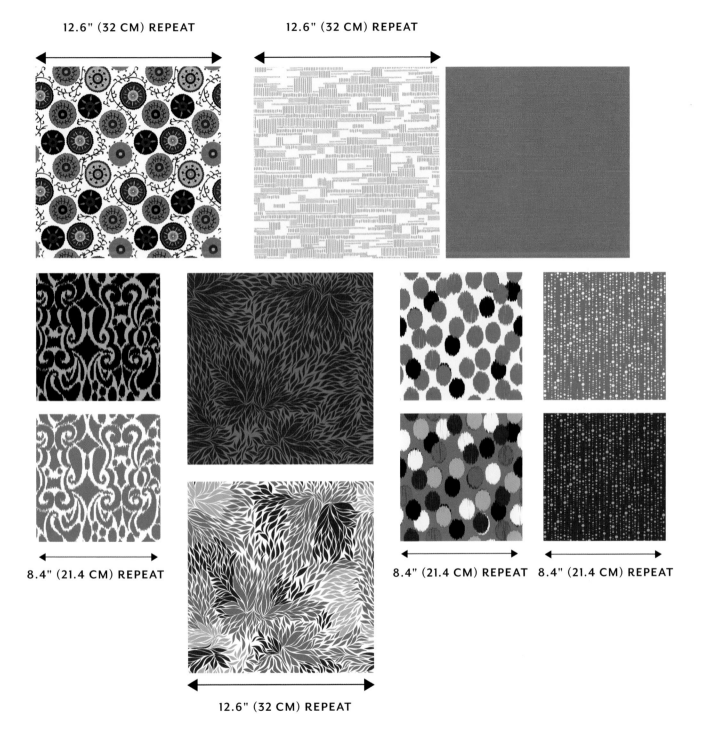

12.6" (32 CM) REPEAT

12.6" (32 CM) REPEAT

8.4" (21.4 CM) REPEAT

12.6" (32 CM) REPEAT

8.4" (21.4 CM) REPEAT 8.4" (21.4 CM) REPEAT

DEVELOPING A COLLECTION

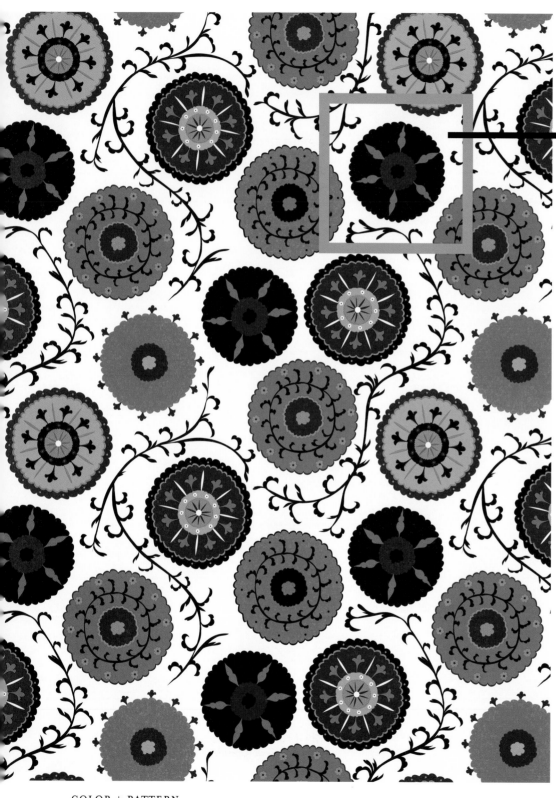

1.7" (4.3 CM)
APPROXIMATE MOTIF SIZE

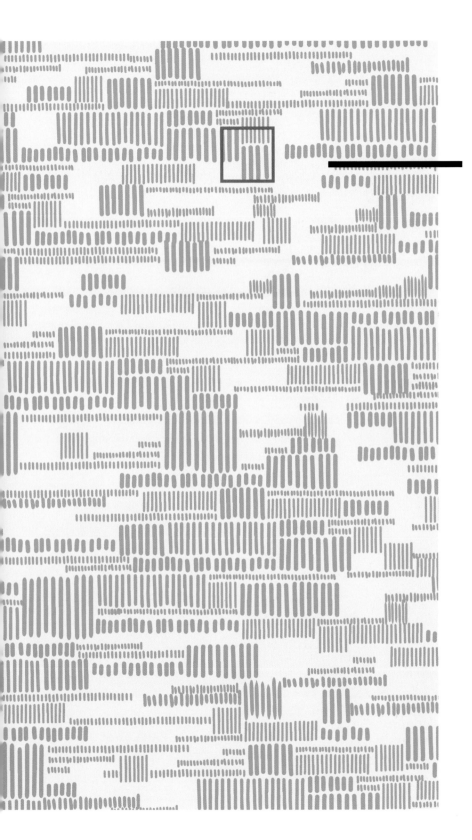

*This detail shows the size variation of the motifs of
two patterns in the collection.*

48

CREATE COHESION WITH STYLE

Style is a great way to pull a collection together. Super-talented Ana Davis is a master at this. Here is Ana's take on how she creates a collection using style as the binding element:

A collection can be composed of any number of designs, each with its own role in supporting or complementing the other prints. For me, a collection often juxtaposes styles and colors, pushing and pulling different aesthetics and playing with how we perceive individual pieces of art.

For me, a collection often includes references to many different illustration styles. Creating artwork is a passionate process, filled with many versions of patterns, a lot of different options, and patterns that don't always work well together. So how do I pull a collection together in a way that is harmonious? The patience to curate is the most important step in editing my work down into a presentable form. Ultimately, each piece within a collection has a role, so curating a collection mostly means tweaking designs so that each print within a group has a specific order in which it is seen, and each piece has a clear relationship to the other pieces in the group.

If I analyze a group of art I've pulled together, I begin to see relationships. I want the group to work as a whole, but I also want the pieces to stand up as individual components. The [patterns] need to play off of one another, have strong individual voices, but also feel like a family. The viewer should be able to see all four elements without strain, so not every piece can be the star of the set. Each piece has a role within the group, whether it is to get our attention, set a theme, offer depth to the group, or support the other patterns.

Paisley Bloom is the piece that tells the overall story of this family of artwork. The piece is happy, folksy, and has a playful composition. It is composed of both bold shapes and tiny details.

Ana has continued this folksy feeling throughout the other pieces of this collection by using motifs and shapes that are reminiscent of traditional Scandinavian and Eastern European shapes.

● *YOUR MISSION*

Develop a collection that's pulled together by style. This can be a range of things that inspire you. Examples are ethnic/global, folk, romantic, floral, geometric, and traditional.

PAISLEY BLOOM

DREAM PAISLEY

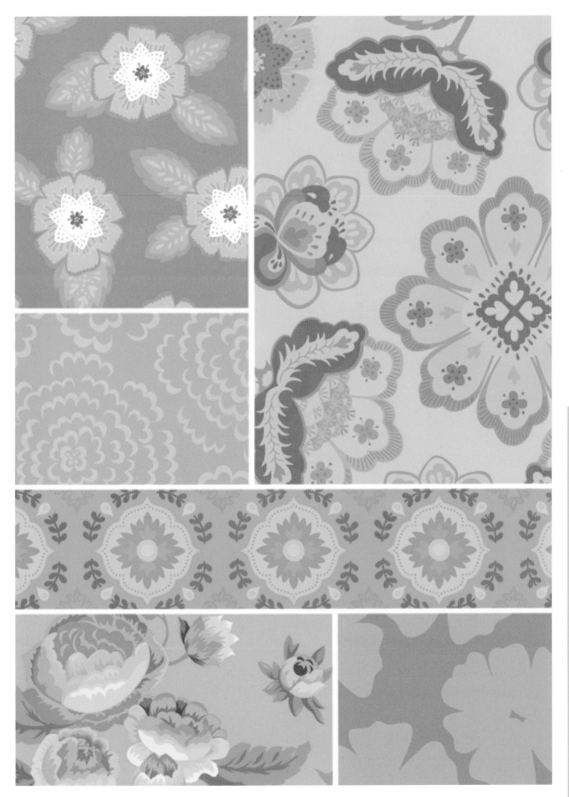

TIP

Remember to play with scale when working on your collection. In many instances, a pattern will take on a totally different personality at a very large scale versus a small scale. Using the same pattern in two different scales can often help to create an eclectic feeling while still feeling cohesive.

This is another instance where it may be beneficial to print and pin your patterns up on the wall and step back to see the work as a whole.

Ana Davis

Ana Davis is a painter, illustrator, and designer whose work is both trend forward and classically inspired. Her collections reflect her lifelong passions: Renaissance painting, traditional textiles, modern design, and the rich traditions of her native Chicago.

Ana Davis uses soft, muted color palettes to help pull her collections together.

49

CREATE COHESION WITH COLOR

Color is everything! (Do you get yet that I am obsessed with color?) Color is a vital language in every kind of design, so of course color is a great way to pull together a collection. In fact, most every collection has a clear color palette. The patterns that comprise the collection are pulled together by sticking with, or very close to, that palette. This in no way means that a collection has to be perfectly matched. Perhaps a collection is pulled together by one strong color like black or indigo blue. The possibilities are endless, but be sure that a cohesive collection will have some sort of color statement that is very clear and compelling to the viewer.

There are many ways to tie a collection together with color. Of course, the obvious way is to create an original palette and use these color and various combinations of the colors in all the prints. A more broad way to use color as a binding element for a collection is to use a palette that is defined by type. For example, a collection of patterns may be colored using pastels as the common thread, or neon colors, or jewel tones.

Color is a great way to create a story and a feeling when pulling patterns of different (but complementary) styles into a collection. The use of different styles while using color as the common thread is a great way to explore adventurous pattern mixing and create an eclectic, interesting feel.

● *YOUR MISSION*

* Create or choose six or more patterns of different but complementary styles from your catalog. This may take some trial and error as you play with how different patterns can sit well together.

* Create a color palette of your choosing or a standard type of palette, such as primary colors, neutral tones or brights.

* Then recolor your selected patterns to work with your palette. Once you begin the process of working with the color, you may discover that some of the patterns are not such a good fit for each other. No problem. This is all part of the process of curating a collection. As this happens, drop in different patterns, recolor, review, and repeat.

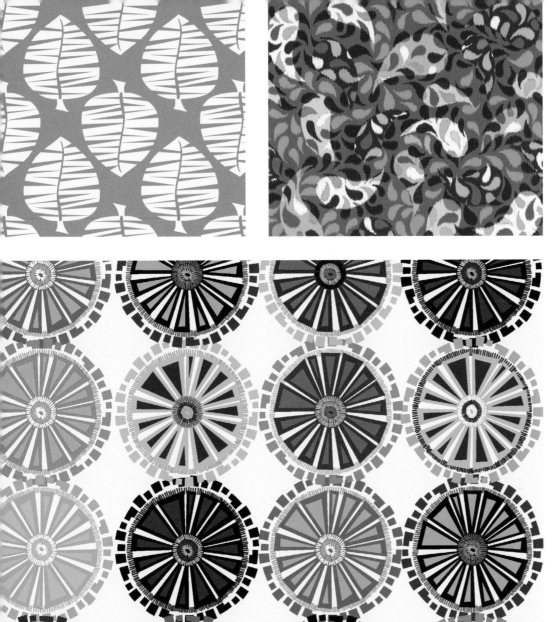

Notice how these seemingly
unrelated patterns are pulled
together with color to create
a dynamic and interesting
pattern collection.

50 CREATE AN ECLECTIC COLLECTION

Now on to my favorite kind of collection—the eclectic collection! That is just personal preference, by the way. So let me explain my bias. I love any collection (of anything, really), that makes you stop and say, hmmm . . . that works great together; I am not sure why, but I can't stop taking it in!

Eclectic collections go against the norm and push notions about how design works. They mix styles, scales, and colors that may seem like they should not work together with mesmerizing and unexpected results. That sounds like fun, right? So how do you go about creating an eclectic collection? As with everything, there are many paths to success. However, one way I like to start is to think about styles that are seemingly disparate. Think traditional mixed with midcentury modern, shabby chic with industrial, bohemian with menswear. These pairings, on the surface, may sound like oil and water, but there's always a clever way to tie different styles together. It's just up to you to create the link!

Two of my favorite designers in the business, Carrie and Morgan of Ampersand Design Studio, are here to share their expert point of view on eclectic collections. These two are geniuses at creating collections that are full of varied styles while still holding true to the Ampersand feeling that is bright, playful, and fun.

Carrie and Morgan often experiment with different mediums to give their collections a truly eclectic feel.

● *YOUR MISSION*

Create an eclectic collection of at least six patterns.

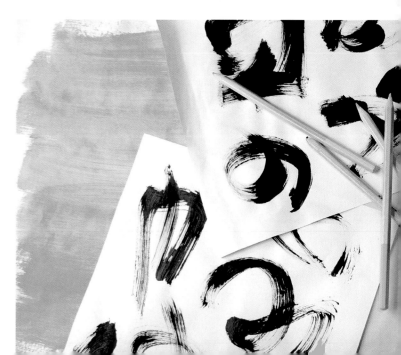

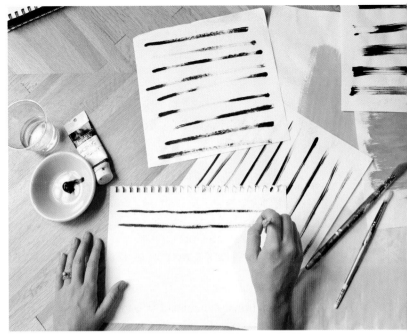

Although not formally trained in painting, Carrie and Morgan aren't afraid to experiment.

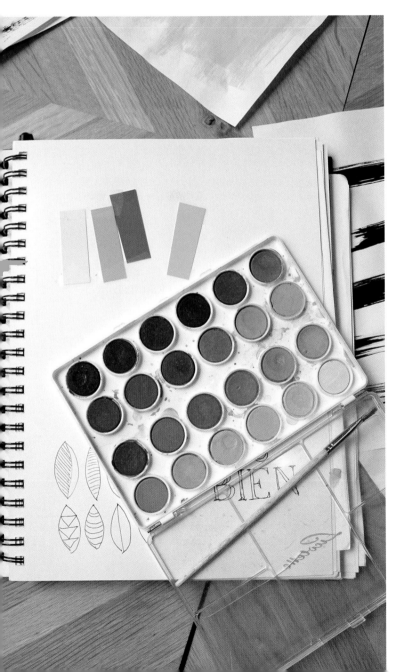

TIP

Think about the feeling you want to evoke within the viewer of your collection. This will help you understand the kind of artwork you need to create, assist in choices about scale, and influence your color choices as you design.

Ampersand Design Studio

Carrie and Morgan of Ampersand Design Studio specialize in surface pattern design, identity design, and stationery products with clients in the home décor, fashion, and baby and kids industries. Their clients include respected names like Target, Bath & Body Works, and Smilebox, as well as great small, local businesses around the country, including cafés, bakeries, photo studios, and fashion boutiques.

Inspired by Henri Matisse, paper cutting is one way Carrie and Morgan create a naïve style with simplicity and texture. Moving from paint to paper, we are always trying to mix up our media and try new ways of creating pattern.

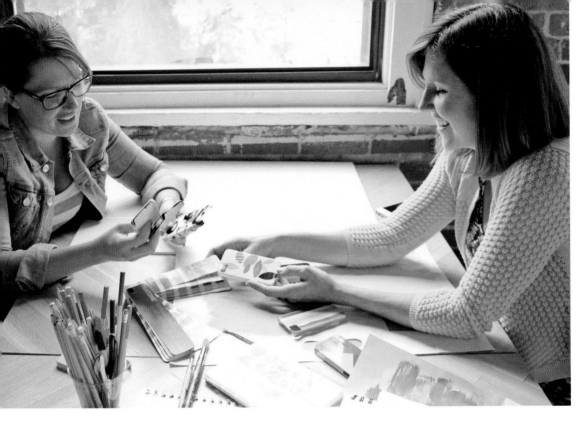

"We are lucky there are two of us, and that our different styles blend well together.

Although our collection of phone cases has a variety of styles, from painterly to paper cut to graphic, the collection is held together with color and a unique point of view," they say.

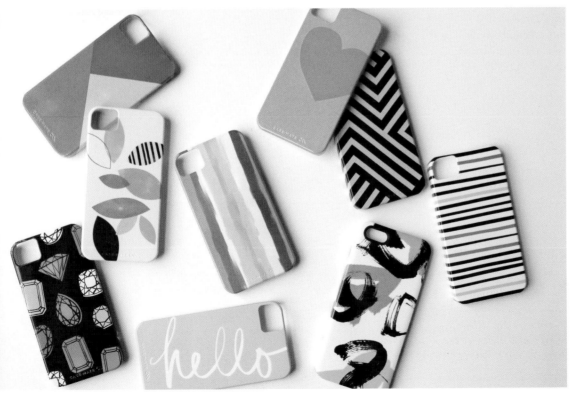

DEVELOPING A COLLECTION

CONTRIBUTORS

RESOURCES

Tools of the Trade

Adobe Illustrator
Adobe.com

Adobe Photoshop
Adobe.com

Wacom
Wacom.com

Pantone
Pantone.com

Trade Shows

Surtex
Surtex.com

Licensing Expo
Licensingexpo.com

Printsource
Printsourcenewyork.com

Indigo
indigo-salon.com

Craft & Hobby Association
cha.com

Print and Online Resources

MOYO magazine
makeitindesign.com

Print & Pattern blog
printpattern.blogspot.com

ACKNOWLEDGMENTS

I have had the privilege to work with and learn from some amazing people on my creative journey. First, thank you to Niki Malek, who is full of faith, patience, and massive amounts of talent. I would not be here today if it were not for the encouragement of the incredibly talented Mary Beth Freet, Tanya Griffin, and Rachael Asimokopoulos. These ladies will always have a special place in my heart as they were instrumental in helping me find my way through this industry. So many people have believed in my talent and encouraged my sometimes overbearing can-do attitude, including the team at *Better Homes and Gardens* and all the licensees I am lucky to call partners. I am so grateful for them all. Finally, I am immensely thankful and proud of the pattern community and creative community online as a whole. I have never found a group of such open, talented, and giving people who are all in the same industry. I am part of a group of amazing, colorful people, and it's awesome!

ABOUT THE AUTHOR

If you're curious as to how I found myself in this colorful, vibrant arena, my story is not unlike many other's . . . pure chance! Fate would take me on a Pacific Northwestern adventure when a job opportunity moved me and my husband to Seattle. What is a girl interested in fashion and art going to do way up there? Maneuver her way into an awesome job at Nordstrom HQ, of course! I landed a job filling in for a colorist who had moved on to a new position. It was like the heavens opened and the angels sang an aria, because, as we all know, color is my jam! I convinced the design director that the position was made for me and should become permanent, and it worked.

Fate wasn't done with me yet. I had really hit the jackpot. I sat in a room with the textile artists on the team. Six months into the job, I started asking if I could help draw something, recolor something, anything to get my hands into what they were up to. They agreed, and soon my job title morphed into colorist/textile artist.

I look back at that time as my graduate degree in pattern design and my MBA all in one. I was designing work that was actually being worn by children and distributed by a major department store nationwide. I was learning the process of how an idea becomes reality. I managed artwork from conception right on through to production. I learned about supply chains, merchandising, cost of goods—all of these experiences inform my work today as an independent designer.

It is with this passion for both design and the business of design that I write this book. These exercises will help you not only to develop your pattern design skills but also to help you view the world with the eyes of a designer. That sounds exciting, right? Learning to create from the heart, yet not in a vacuum, will make your designs strong, make your eye more discerning, and thus make the final application more impactful. I hope you are ready to have some fun and explore, both in and out of the studio.

INDEX